W9-CQG-856

cow•parade®

CowParade Denver

CowParade Holdings Corporation

ORANGE FRAZER PRESS
Wilmington, Ohio

Additional copies of *CowParade Denver* may be ordered directly from:
Orange Frazer Press
P.O. Box 214
Wilmington OH 45177

Telephone 1.800.852.9332 for price and shipping information
Website: www.orangefrazer.com

Library of Congress Control Number: 2006932353

CowParade President | Jerry ELBAUM

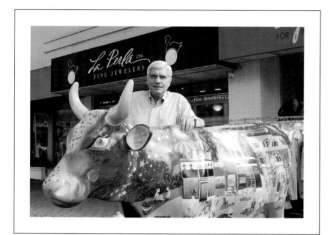

"Minimoos" hanging from the lampposts in Larimer Square! What a spectacular display of CowParade art. All of the venues in Denver were just great for our grazing bovines. And the artists outdid themselves. CowParade Denver has proven to be one of our most memorable exhibits. All our thanks go to this magnificent city and its Mayor, John Hickenlooper, whose support was very much appreciated, to United Airlines, the presenting sponsor, and to all of our other sponsors without whom the event would not have been possible.

Denver represents the 47th CowParade beginning with Chicago in 1999. Over 4000 of our cow creations have appeared on five continents in such cities as Tokyo, London, Paris, Lisbon, New York, Sydney, Auckland, Cape Town, Atlanta, Houston, Moscow, Prague, Mexico City, Buenos Aires, Boston, Kansas City, San Antonio, Dublin and Barcelona. New events for 2007 and 2008 are in various stages of production in communities in this country, South America, Europe, Mexico, Japan and China. CowParade has truly become the "Olympics" of public art. We have brought smiles to the faces of tens of millions of people around the world. Our cows have served to bring together in a continuing exhibition so many diverse cultures, languages and creative talents. The whimsical and friendly dairy cow, which doubles as the CowParade canvas, is a common denominator to which people of all backgrounds and ages can relate. Its ideal dimensions and personality engender artistic creations which serve to both amuse and instruct us. What truly amazes me is that virtually all of the cows in Denver, as well as those which have appeared in our other exhibits, are one-of-a-kind originals. They attest to the immense creativity which all of us possess in one form or another.

Please enjoy looking at our Denver "girls." They are great!

Sincerely,

Jerry Elbaum

President, CowParade

Mayor | John HICKNLOOPER

Mayor John W. Hickenlooper

Cow Sponsored by Mayor Hickenlooper

Greetings:

As Mayor of the City and County of Denver, it is my pleasure to welcome the world renowned CowParade to the Mile High City.

While CowParade has been produced in more than 25 cities around the world, Denver's CowParade reflects the energy and excitement of the Mile High City. From our landmarks to our hometown sports teams to our local "moovers" and shakers, each cow captures a different aspect of Denver's history and culture.

Not only do we have the opportunity to enjoy these colorful fiberglass bovines while they graze our streets as public art, the cows' impact will be felt long after they have left our streets. Through the public auction after the conclusion of the public display, CowParade has the potential to raise approximately $500,000 for dozens of local charitable organizations including Denver's Road Home, our 10-year plan to end homelessness, and CowParade nonprofit partners such as the Children's Museum of Denver, the Denver Zoo, the Cherry Creek Arts Festival and the Denver Foundation's Eagle Fund.

We hope you enjoy this "udderly" unique partnership among our local artists, nonprofit organizations and business community.

Sincerely,

John W. Hickenlooper
Mayor

United Airlines is proud to serve as the title sponsor of CowParade Denver 2006. We have a long history of supporting the Denver community and of sponsoring programs that add to its quality of life.

One hundred life-size cows, including United's herd of 15, will delight millions of people and will help raise significant funds for local nonprofit organizations. Once positioned in downtown Denver, Cherry Creek and Stapleton, these unique fiberglass creations are now captured in this colorful book.

CowParade is considered one of the world's largest and most successful public art events, and they have occurred in more than 12 international cities. On behalf of all United employees, we were honored to bring this world-class tradition to Denver.

Sincerely,

Jim Kyte

Jim Kyte
General Manager—Denver International Airport
United Airlines

COWPARADE® HAS CAPTURED THE HEARTS and imaginations of hundreds of millions of people around the world over the past seven years, bringing art out of the museum and onto the streets in an 'udderly unique' way.

Featuring its famous life-size cow sculptures, CowParades have literally taken over the cities of Chicago, New York, London, Buenos Aires and Paris just to name a few, turning their streets, parks, and other public places into stampedes of art! Each CowParade event takes on the distinct character of the city, region and its artists; the cows are merely beautiful and fun canvases on which the artists explore their city's unique culture and history, while showing off the full extent of their creativity.

The essence of CowParade is the artistic creativity it generates and the wonderful smiles brought to the faces of children and adults alike. CowParade Chicago event organizer Peter Hanig best captured the essence of the public art movement led by CowParade:

"Art is about breaking down barriers. It gets people to feel, to think, to react. So when you come across life-sized cow sculptures that have been covered in mirrors or gumdrops, Cows that have been painted with elaborate themes or transformed into something else entirely, you can't help but stop and think about what it means. All your preconceived ideas go out the window. Suddenly people see that art can be fun and that art can be interesting to everyone, not just people who frequent museums."

HISTORY OF COWPARADE.

HEADQUARTERED IN WEST HARTFORD, Connecticut, CowParade is the world's largest and premier public art event. Since Chicago in 1999, CowParade has visited over 40 cities on five continents. While the basic cow sculptures remain the same, each city's artists are challenged by the creations from past events, inspired by the culture and history of their respective cities, and moved by their own interpretation of the cow as an object of or canvas for art.

WHY COWS?

THEY ARE SIMPLY UNIQUE, three-dimensional canvases to which the artists can easily relate. There is really no other animal that can adequately substitute for the cow and produce the level of artistic accomplishment evident in the multitude of CowParade events. The surface area and bone structure of the CowParade sculptures are just right, as are their heights and lengths. Each form—standing, grazing, and reclining—has unique curves and angles, making them ideally suited to all forms of art. They have now been reinterpreted, altered, and morphed into over 5,000 one-of-a-kind works of art by artists worldwide.

Equally important, the cow is an animal we all love. The cow is whimsical, quirky and never threatening. She provides us with milk, is the source of heavenly ice cream, and is the inspiration for one of our first words—"mooo." From early on in life, we all have a connection with the cow in one way or another.

WHO ARE THE ARTISTS?

COWPARADE EVENTS ARE OPEN to artists of all backgrounds and disciplines.

Professionals and aspiring artists, painters and craftsman, and artists of all ages are invited to participate.

CowParade events have attracted renowned and celebrity artists including Peter Max, Leroy Neiman, Patrick Hughes,

Romero Britto, and Soprano's star Frederico Castellucio.

Each event begins with a "Call to Artists" inviting local and regional artists to submit designs. Parameters for the designs are set wide to encourage a broad range of art and artists. There are restrictions only against blatant advertising, political slogans, religious messages and inappropriate images. A large portfolio is created from which event sponsors select their desired artist and design. The common denominator to each event is the flood of designs that pour in as the submission deadline approaches. Sponsors' biggest challenge is picking just one design. For every official cow produced, there are ten design submissions that do not get chosen. 2,500 designs were submitted for CowParade New York alone and, to date, over 25,000 artists from around the world have applied to paint a cow.

What Happens to all of those Cows?

AT THE CONCLUSION OF EACH EVENT, the cows get 'rounded up', refurbished, and sold at auction for the benefit of non-profit organizations. Premier auction houses such as Christie's, Sotheby's and Phillips Auctioneers have all conducted CowParade auctions, which have raised over $10 million thus far. The CowParade Chicago auction raised an amazing $3 million for charity, including $1.4 million from the internet auction hosted by the *Chicago Tribune* and $2.1 million at the live auction conducted by Sotheby's. The average bid price on the 140 cows was nearly $25,000, with the top cow, HANDsome, selling for $110,000. The CowParade New York live auction raised an equally impressive $1,351,000.00 benefiting several New York City charities. Tiffany Cow garnered the top bid at $60,000. Past auction purchasers include Oprah Winfrey, Ringo Starr, and Princess Fiyral of Jordan. CowParade London 2002's auction drew a record 1,500 attendees.

After the auctions, winning bidders bring the cows to their new homes. Cows have been spotted at ski resorts and beach homes, on farms and ranches, in backyard gardens and living rooms, and even building and residential rooftops. You just never know where one of the cows will appear.

On the Horizon...

COWPARADE TRAVELS TO THE WORLD'S most exciting cities in 2006 and beyond. In 2006, CowParade events were staged in Wisconsin, Boston, Massachusetts; Denver, Colorado; Paris, France; Edinburgh, Scotland; Lisbon, Portugal and Buenos Aires, Argentina. On the horizon for 2007 and beyond are events in Miami, Florida; Rio de Janeiro, Brazil; Guadalajara, Mexico and China.

How the Cows Came Home to Denver

One would have thought that CowParade would have grazed into Denver years ago. After all, Denver started out as the typical western "cow town" and even today has a strong agribusiness sector based around the cattle industry. There were several efforts to bring CowParade to Denver in the 1990's, but it wasn't until 2005 when all the trails seemed to converge.

Ryan O'Shaughnessy, a Denver native, was working in Houston in 2001 when CowParade came to the streets there. Upon returning to Denver, he thought CowParade would be an ideal avenue to help raise funds for the Eagle Fund, a designated fund of the Denver Foundation he and a number of other friends established to support youth and educational programs. Ryan called the folks at CowParade Holdings in the Hartford area.

While the Eagle Fund had a lot of enthusiasm, they needed professional assistance in planning, managing and producing CowParade. A call went out to Broomfield-based Creative Strategies Group (CSG). CSG is the region's leading event marketing and sponsorship agency specializing in festivals and special events. Given their experience working with such events as the Cherry Creek Arts Festival, Colorado Garden & Home Show and the Pasadena Tournament of Roses, CSG was the ideal choice to with which to partner.

So in early spring 2005, the planning and preparation for bringing CowParade to Denver began. CowParade Denver 2006 was designed to accomplish three desired objectives:

- Create a temporary public art display that would entertain and delight, and draw visitors into the streets and public spaces of Denver

- Support Colorado's remarkable artisan community by showcasing their creativity and talents as well as contributing nearly $100,000 in honorariums

- Generate much-needed contributions for deserving Colorado charitable organizations through the auctioning of the cows at the conclusion of the public display

Planning continued with the recruitment of the Pasture Hosts in Downtown Denver, Cherry Creek and Stapleton where the cows would be placed on display. Four nonprofit partners - the Cherry Creek Arts Festival, Denver Zoo and Children's Museum of Denver, were selected to join with the Eagle Fund in planning and producing the Charity Auction.

With their vast network of relationships with the local artist community, the Cherry Creek Arts Festival took on the responsibility for the "Cattle Call for Artists" in the fall of 2005. More than 400 designs were submitted from which the 100 within this book were selected. And what a remarkable job the artists did. The cows reflect the character and spirit of Colorado in so many unique ways.

But CowParade Denver only became a reality because of the commitment of its cow patrons and event sponsors, especially

United, Stapleton, the Colorado Beef Council and Macy's. Without their enthusiastic support, CowParade Denver 2006 would have never taken place.

On behalf of all those who helped in creating and producing CowParade Denver, we hope you enjoy the images in this book and recall with pride when the cows came home to Denver.

NON PROFIT PARTNERS:

The Children's Museum of Denver

The Denver Zoo

Cherry Creek Arts Festival

The Eagle Fund of the Denver Foundation

FEELS DIFFERENT

DOWNTOWN DENVER HERDS

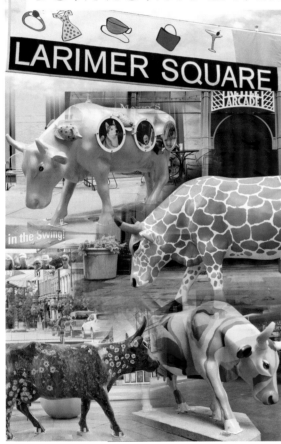

WATERING HOLES

- 16th Street Mall

- Larimer Square

- Writer Square

- Tabor Center

- Denver Pavilions

Udderly Tranquil | Irene WATTS

Sponsor: United

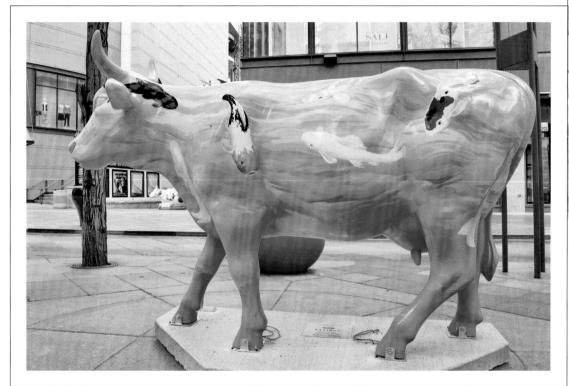

Colorado Stamp(ede) | Douglas ROUSE

Sponsor: Colorado Beef Council

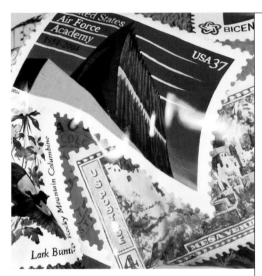

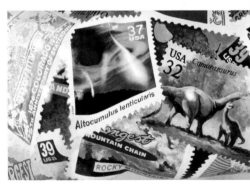

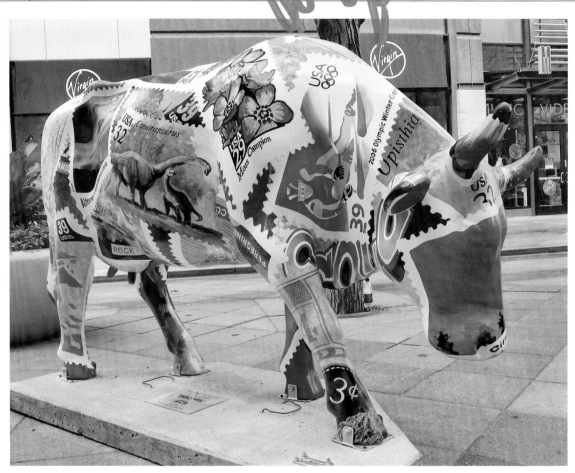

Sponsor: Stortz Design, Inc.

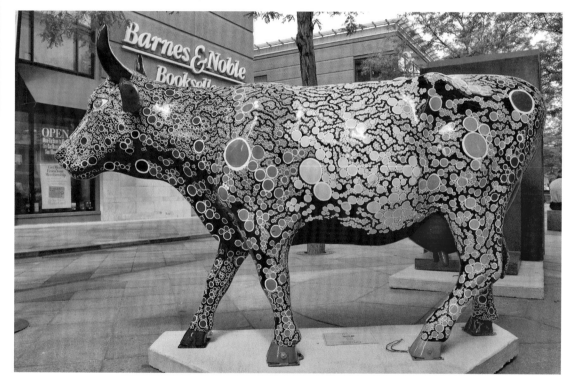

It's Your Moove | Barry GORE

Remember—
always play to WIN!!
—Barry

Sponsor: Mortenson

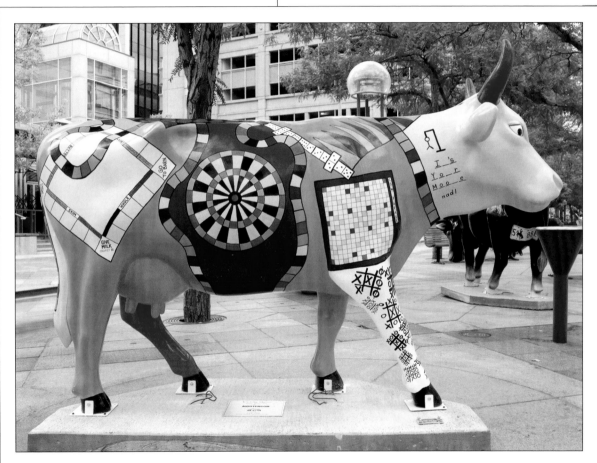

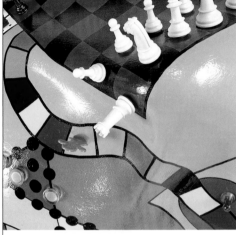

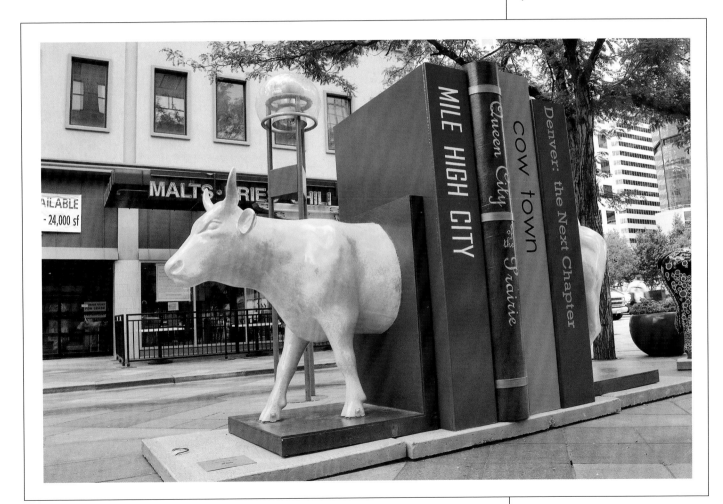

Wired Cow | Kim HARRELL

Sponsor: CowParade Denver

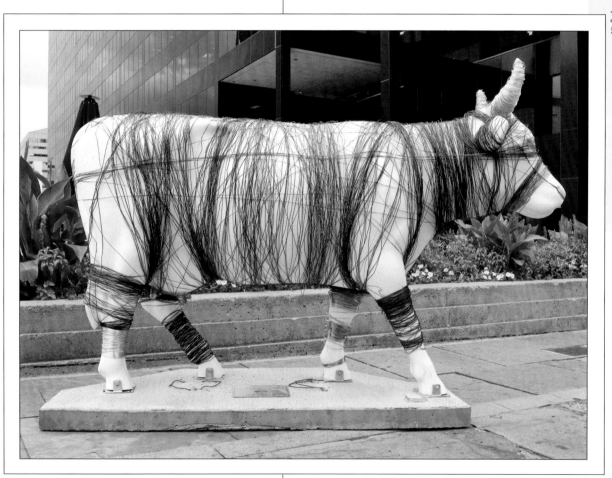

The Next Stage | Lisa HUFF

Sponsor: Wells Fargo

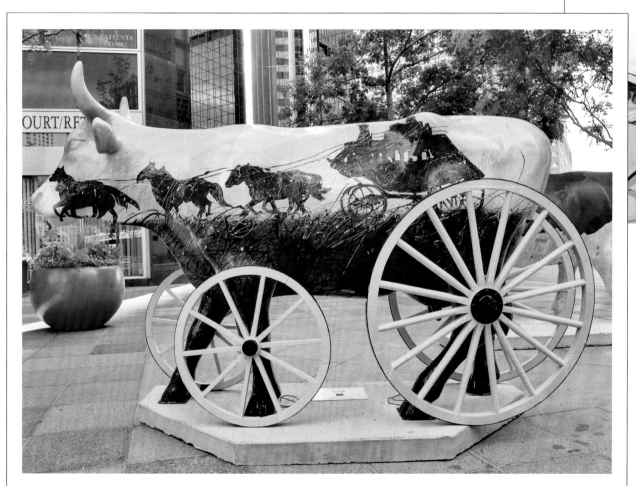

Breaking Moos | Brent DILWORTH

Sponsor: *Rocky Mountain News*

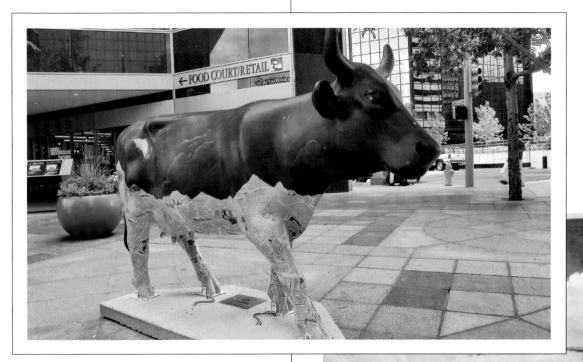

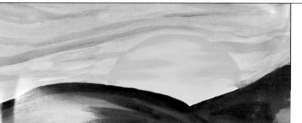

16th STREET MALL

Denver, Moo Mean the World To Us | Sean GRIFFIN

Sponsor: United

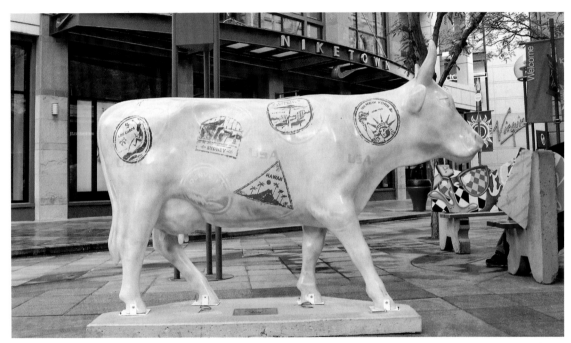

Cow In a Candy Store | Pam SIRKO

Sponsor: Capital Pacific Homes

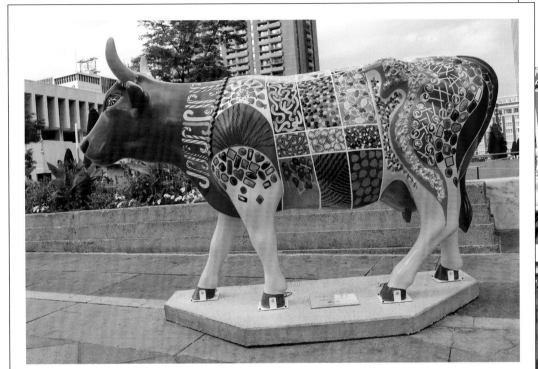

Alpine Explosion | Sabine BAECKMANN-ELGE

Sponsor: CowParade Denver

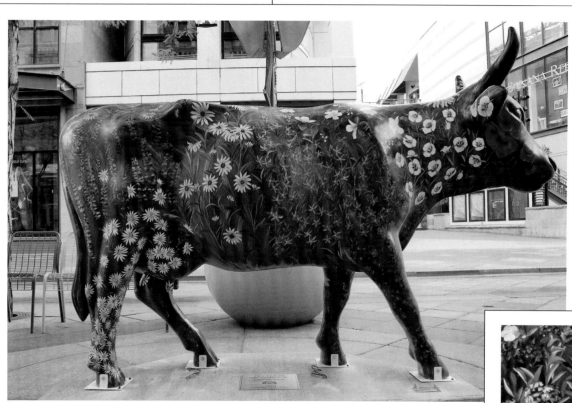

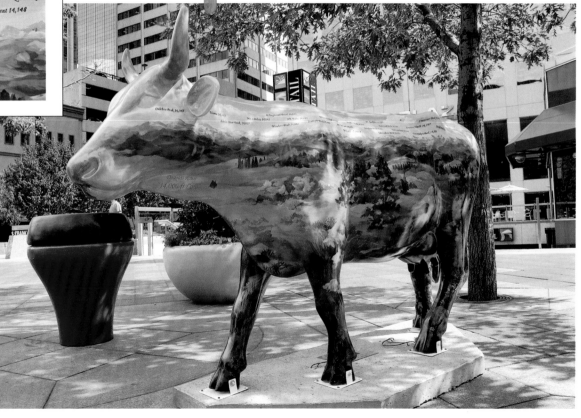

Fifty-Moo-Eighty | Jen THARIO

Sponsor: Denver Metro Convention & Visitors Bureau

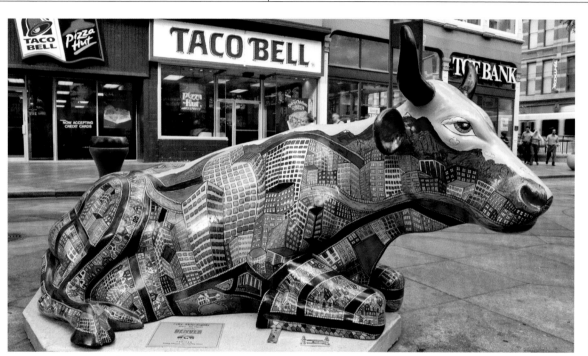

Sponsor: CowParade Denver

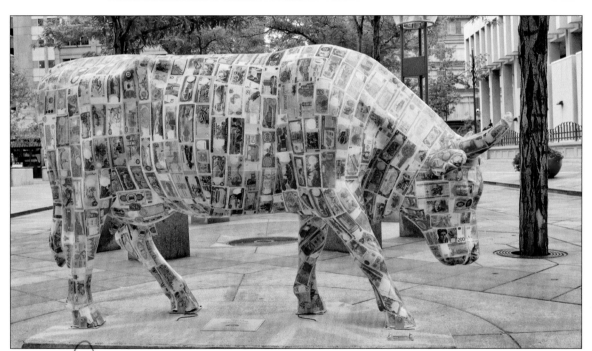

Cheryl 06

16th STREET MALL

The Cow Boys | Monte MOORE

Sponsor: Wyoming Travel and Tourism

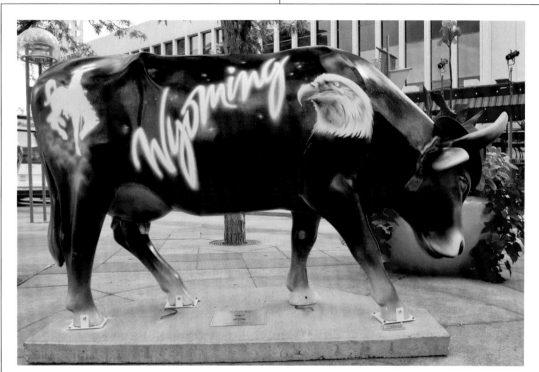

Bucky Broncow | Jay PAONESSA/
Luis Felipe MOSQUEIRA

Sponsor: United

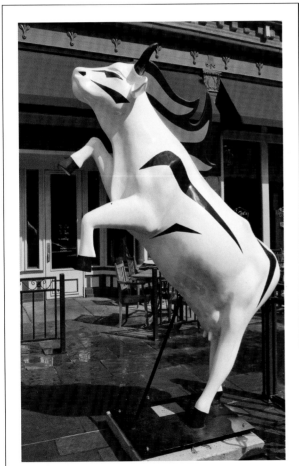

Bo-Fhind | David John DREW

Sponsor: CowParade Denver

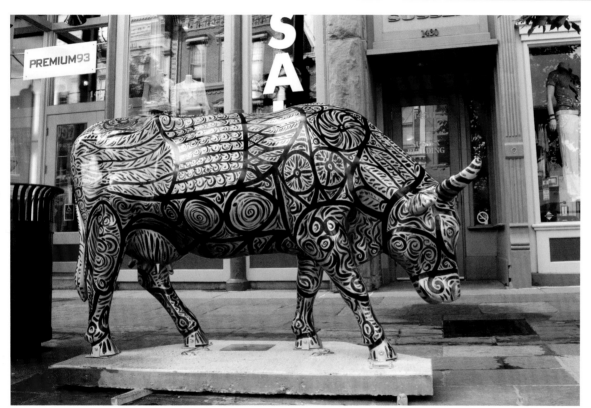

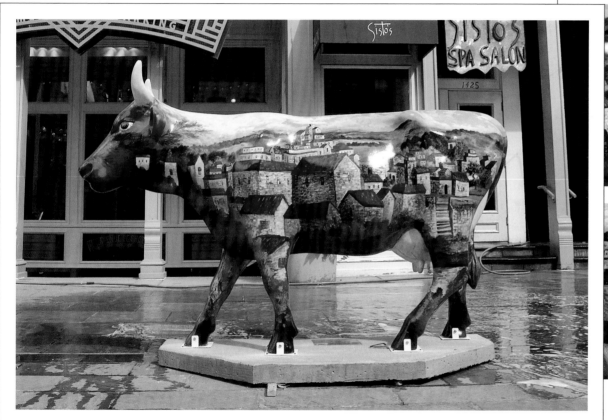

LARIMER SQUARE

Hula Cow! | Jay PAONESSA and Luis Felipe MOSQUEIRA

Sponsor: United

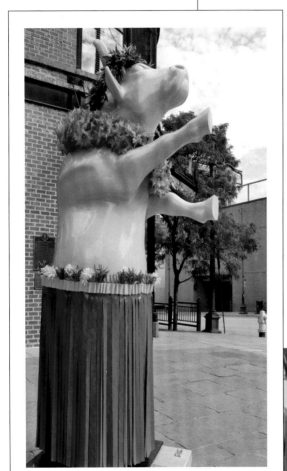

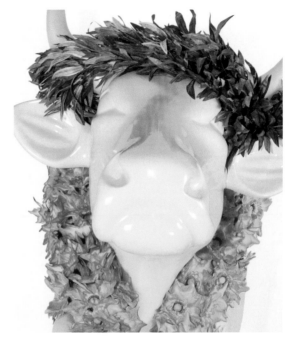

Sponsor: Larimer Square

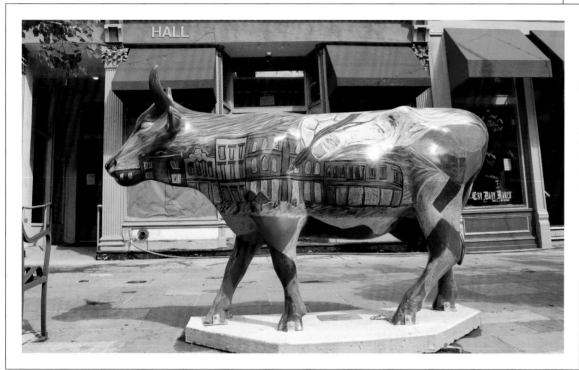

LARIMER SQUARE

33

Talavera Cow | Michel REEVERTS

Sponsor: Colorado Beef Council

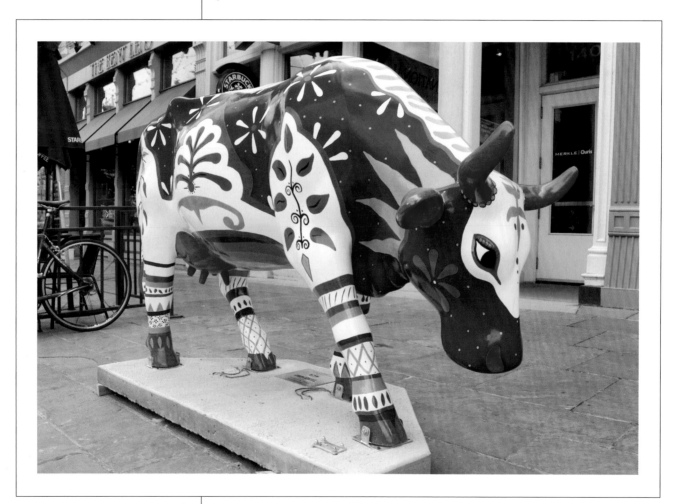

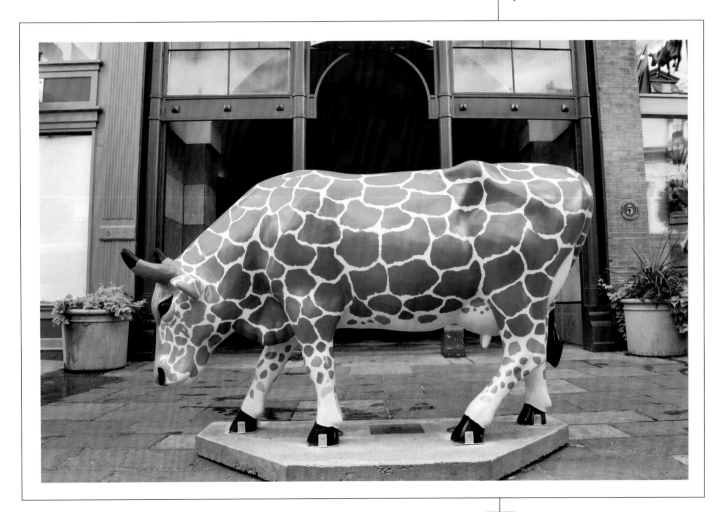

LARIMER SQUARE

Mini Moos

Colorado Flower Cow | Kepner Middle School

Punk Cow | Skinner Middle School

Immigration Cow | Bruce Randolph Middle School

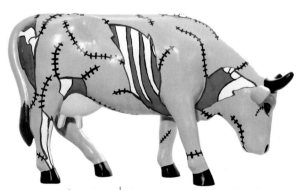

Hades Cow | Skinner Middle School

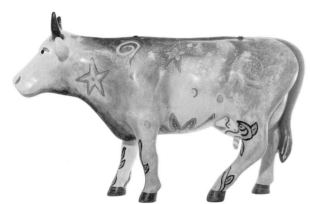

Sunnyside | DPS Superintendent's Team

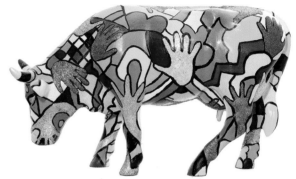

Skittles | Centennial K-8

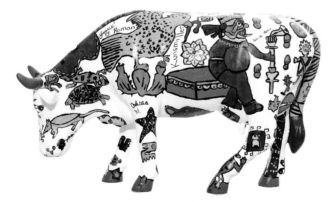

Miss Raquel Ramirez-Cowhlo | Kunsmiller Middle School

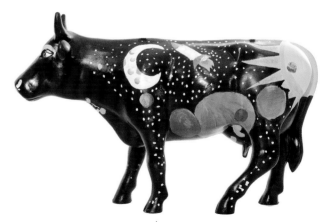

Space Cow | Denver School of the Arts

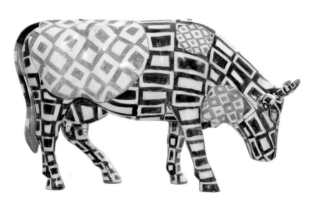

The V7 | Kaiser Elementary School

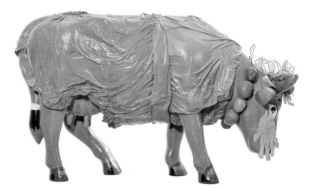

Frida Cow-Low | Place Middle School

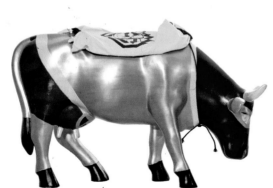

Kung Pow Cow | Lake Middle School

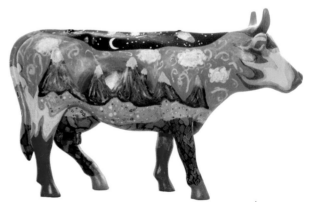

Laura the Crazy Cowlorado Cow | Slavens Middle School

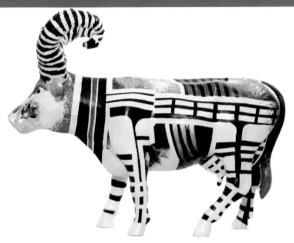

Ringo, the Tattoo Cow | Denver School of the Arts

Pac-Man Cow | Grant Middle School

Brick Cow with Orange Stripe | Denver School of the Arts

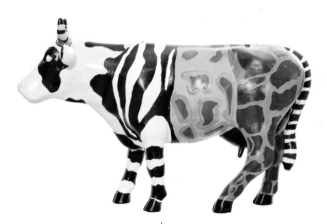

African Cow | Grant Middle School

MINI MOOS

Glazed Black and Blue Moo | Steven ALTMAN

Sponsor: CowParade Denver

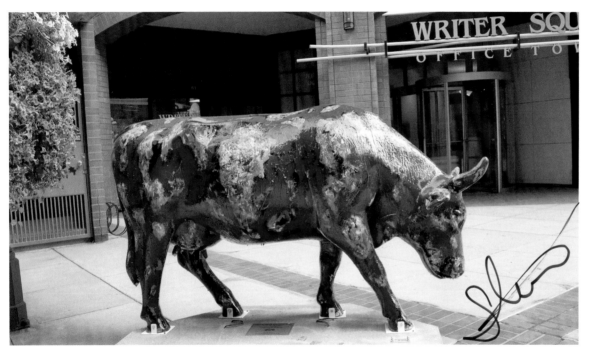

Aspen Eyes | Timothea BIERMANN

Sponsor: Wink Optometry at Aspen Eyewear

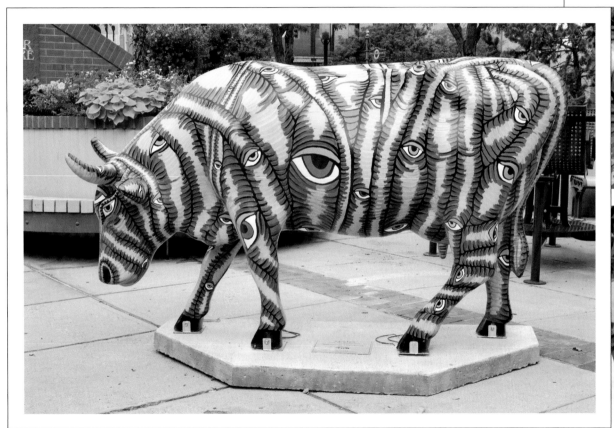

Rhythm and Moos | Jen THARIO

Sponsor: Starbucks

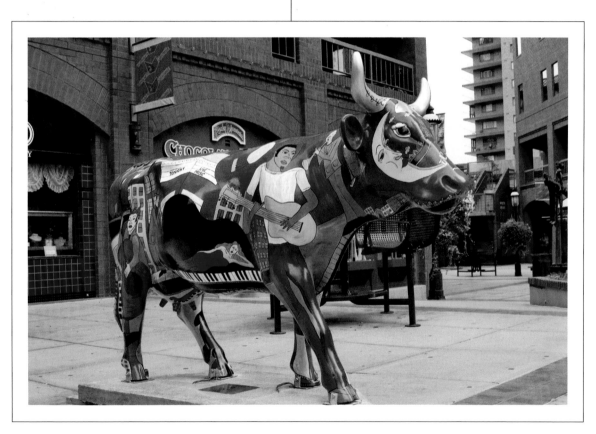

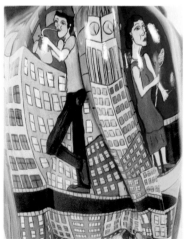

Cowlorado the Beautiful | Andrean ANDRUS

Sponsor: Sill-TerHar Motors

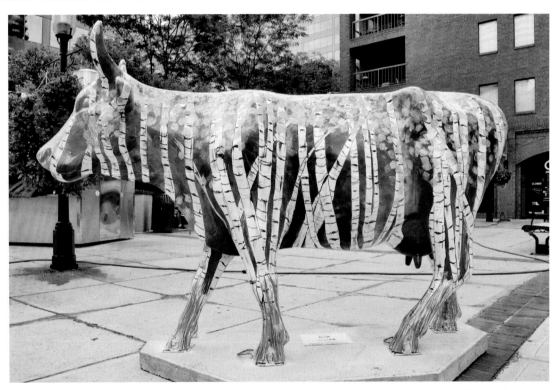

San Luis Valley Cow | Kym ALLISON

Sponsor: CowParade Denver

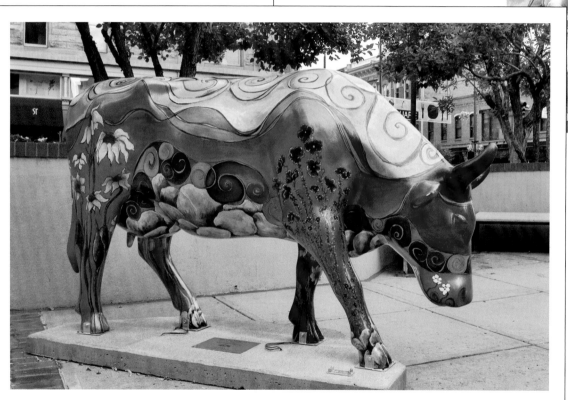

Malvi's Muse | Jennifer MOSQUERA

Sponsor: CowParade Denver

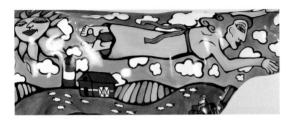

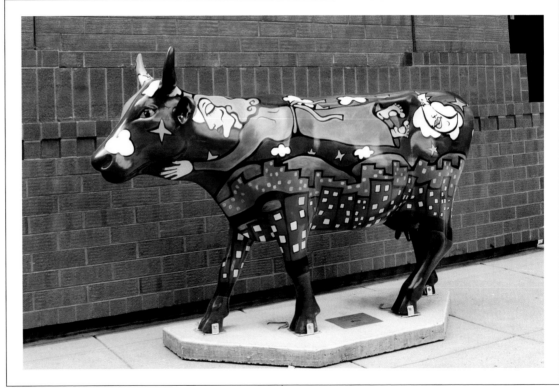

Ted is Cooler | Jay PAONESSA/ Tim SMITH

Sponsor: United

Connla of the Golden Hair | Sandie DOHERTY

Sponsor: CowParade Denver

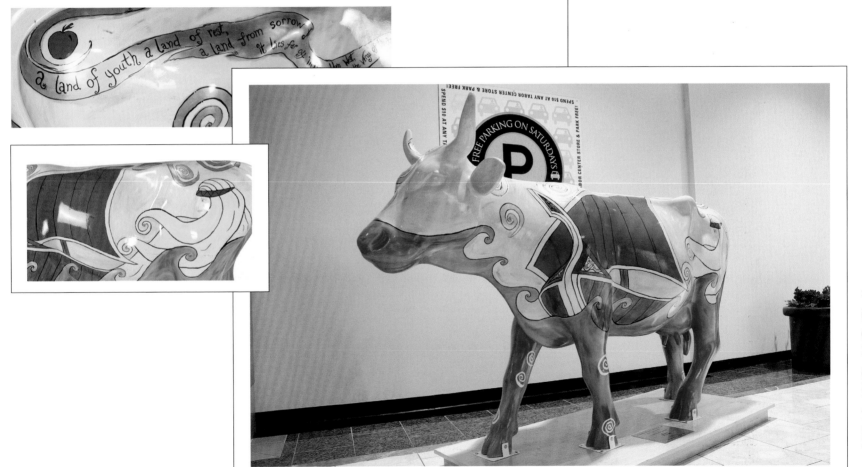

Cownterfeit | Robbin MERTA

Sponsor: CowParade Denver

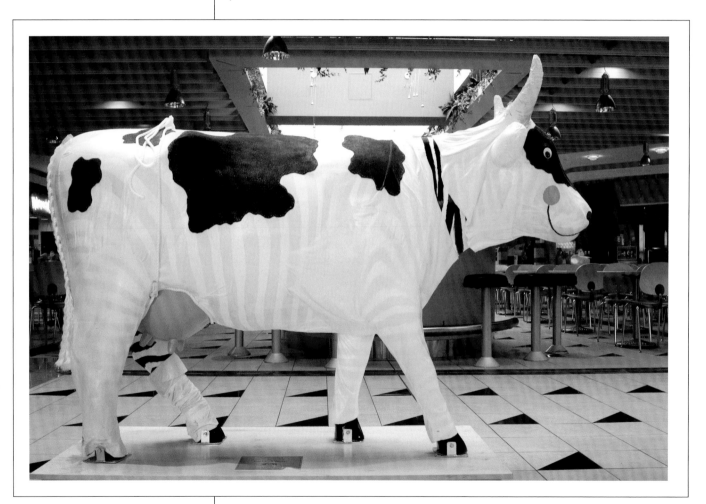

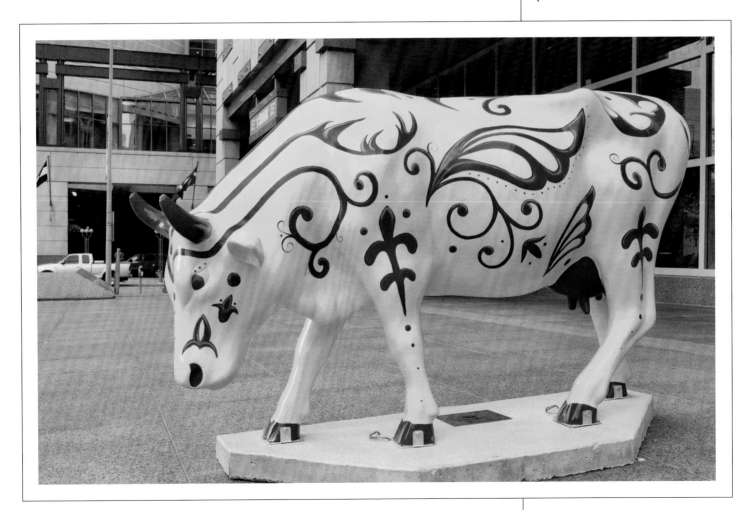

TABOR CENTER

49

Jumper's Night Off | Valerie GRANERE

Sponsor: CowParade Denver

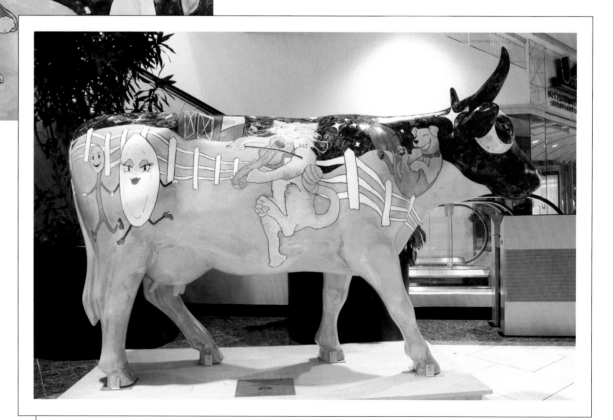

Sponsor: CowParade Denver

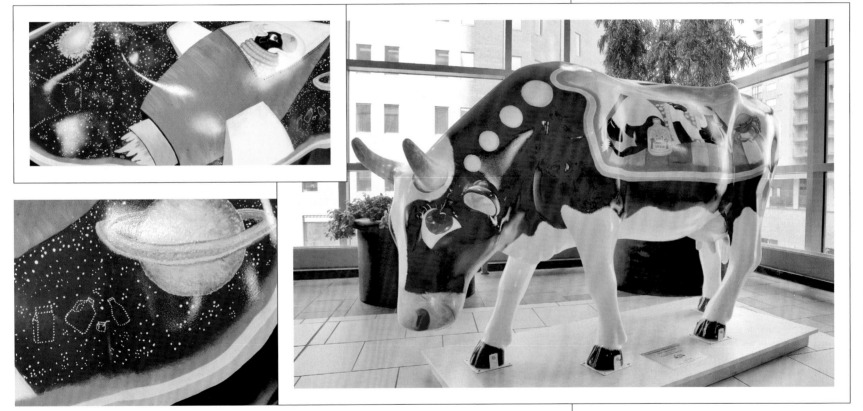

Zippo | Kim POLOMKA

Gay & Lesbian Fund for Colorado

Kim POLOMKA '06

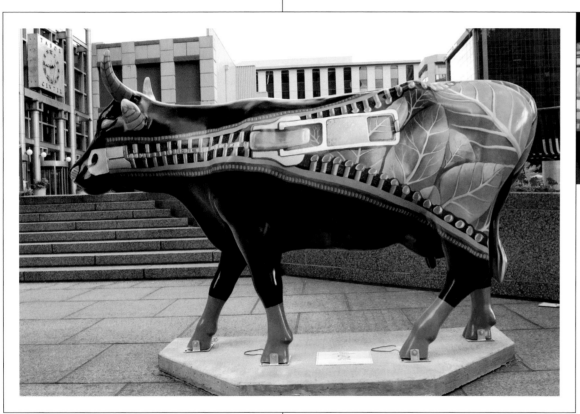

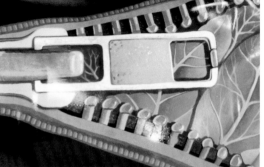

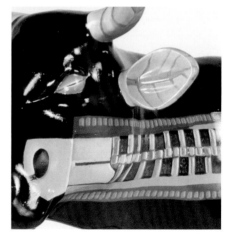

Cow Chips | Amelia CARUSO

Sponsor: CowParade Denver

TABOR CENTER

CrOWchet | Marcy KERCHAL

Sponsor: CowParade Denver

Sponsor: CowParade Denver

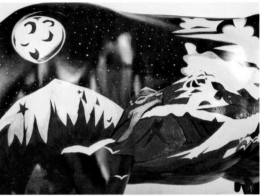

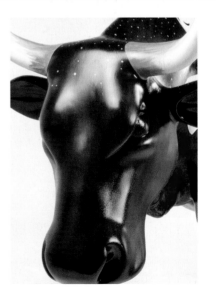

TABOR CENTER

ReMOOse and RecyCOW | Scott LYON

Sponsor: CowParade Denver

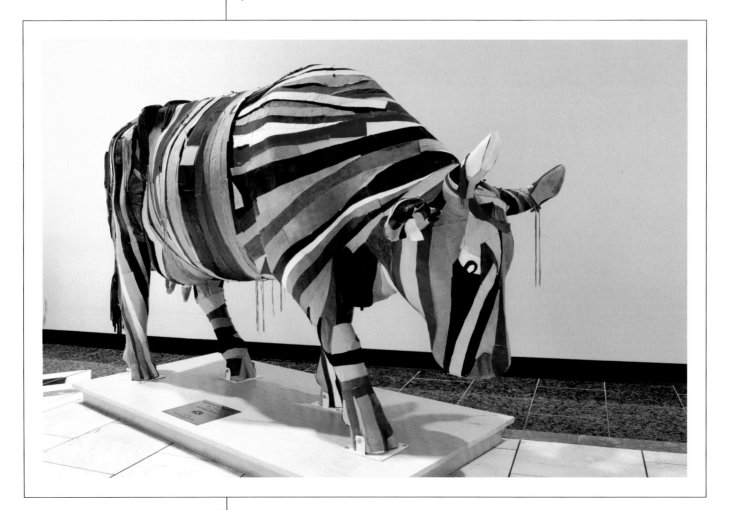

Sponsor: KS1075

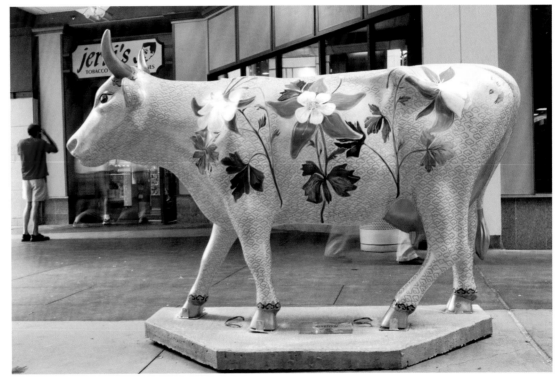

Mt. Bovine, Cowlorado | Joanne ORCE

Sponsor: Today's Country 98-5 KYGO

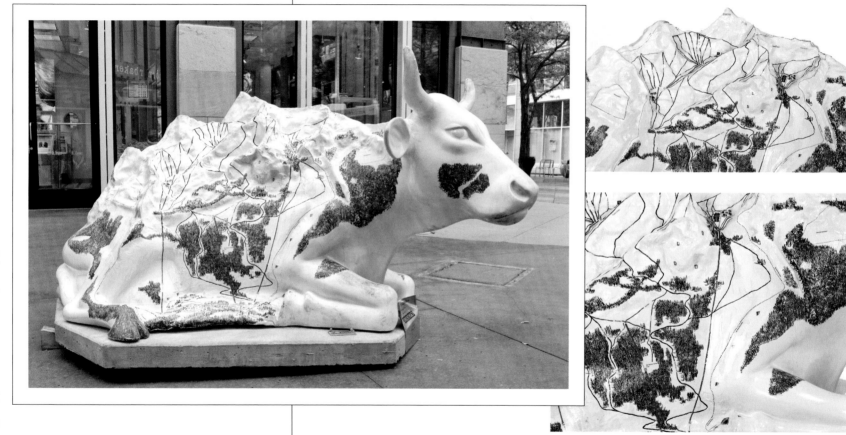

Sponsor: Orange Glo International, Inc.

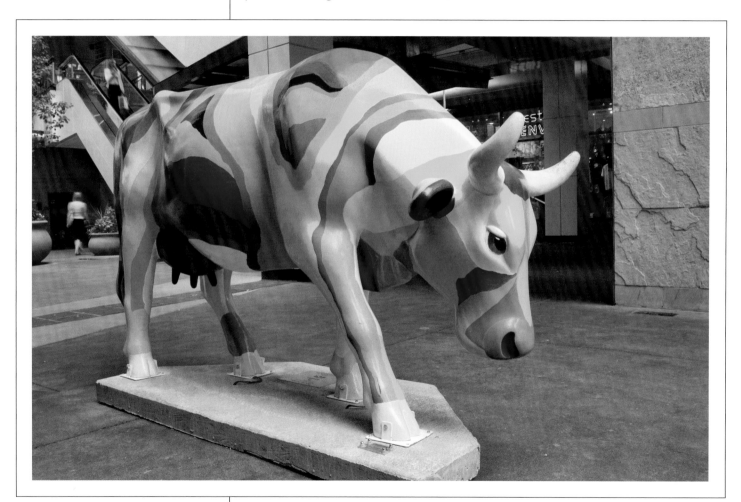

Yellow SubMOOrine | Tanya HAYNES

Sponsor: CowParade Denver

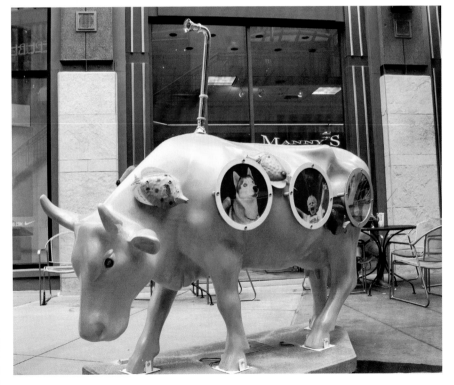

Cow Town USA | Monte MOORE

Sponsor: Colorado Beef Council

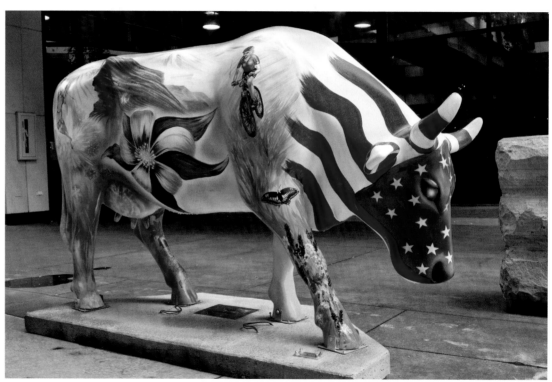

CHERRY CREEK HERD

WATERING HOLES

- Cherry Creek Shopping Center
- Cherry Creek North

shopcherrycreek.com

Mootercycle | Joseph McCULLOUGH

Sponsor: Left Hand Brewing Company

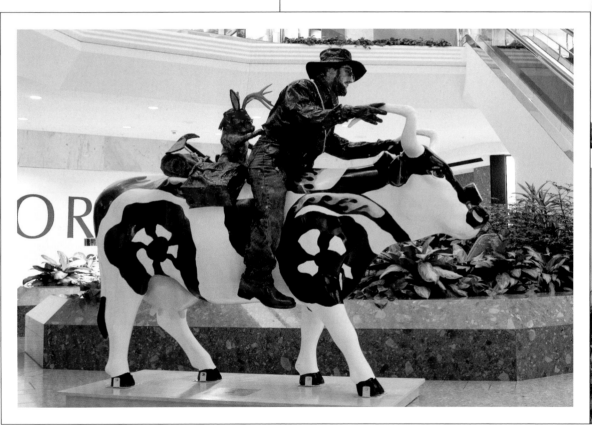

Classic Cowvertible | Tim SMITH/ Patrick MACKLIN

Sponsor: Creative Strategies Group

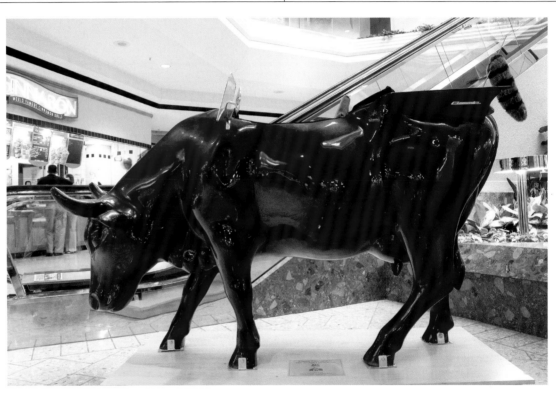

Jo-Veal | Malcolm FARLEY

Sponsor: Willie 92.5FM, Wide Open Country

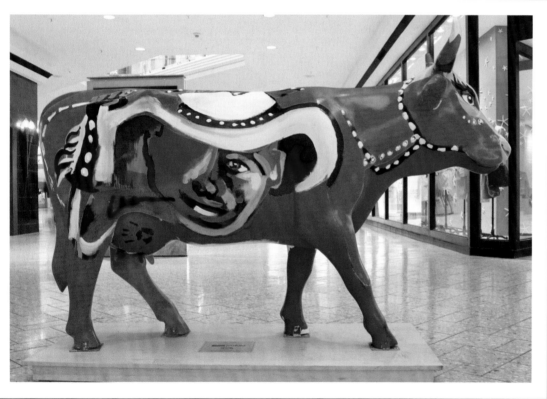

Sponsor: United

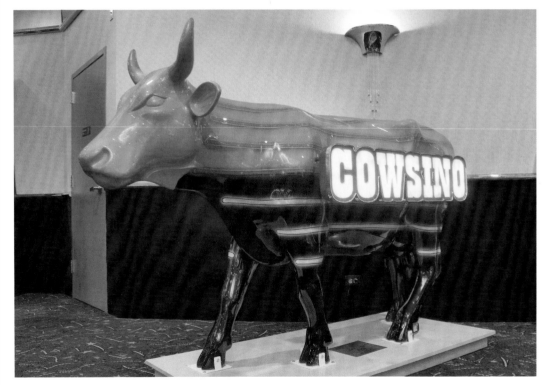

Front Range Cow

Barbara HUDSON, Leroy McKAY, Thomas McKAY, and Liz ABBOTT

Sponsor: *The Denver Post*

Barb Hudson

Tom "MAD COW" McKay

Liz Abbott got pie?

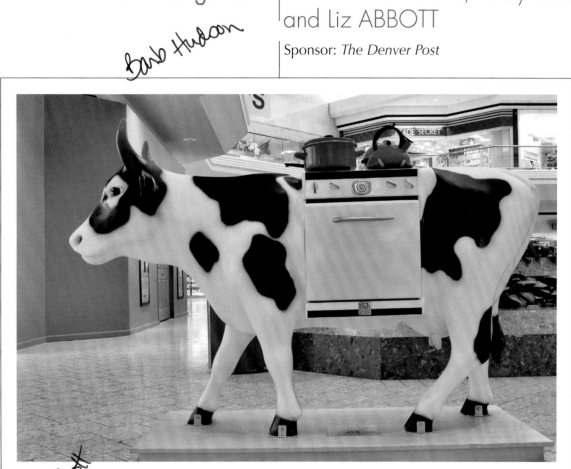

Rocky Mootain High | Jordan MESTAS

Sponsor: Colorado Beef Council

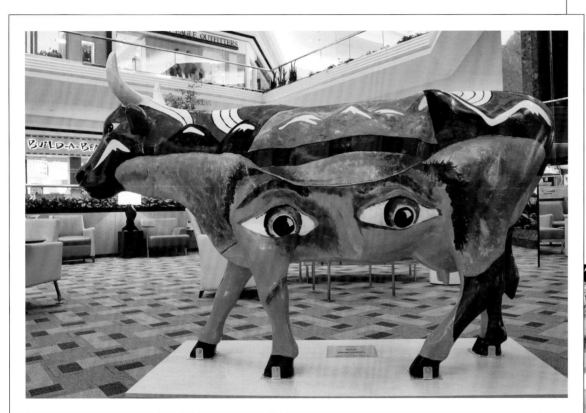

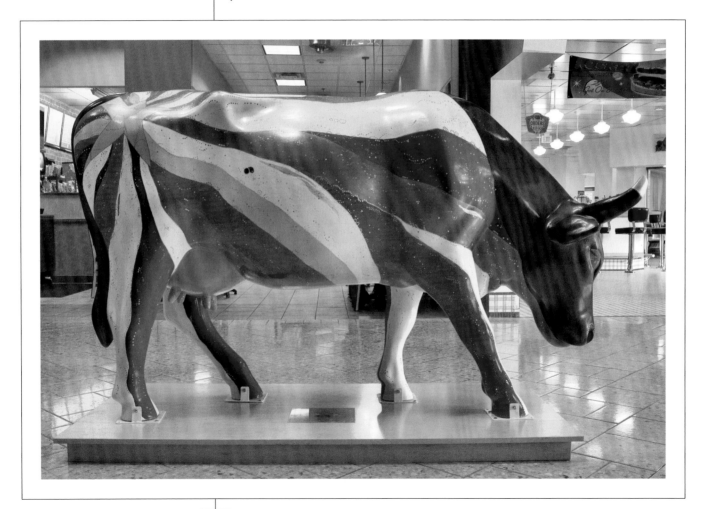

Evening Star | Kit SALWAY

Sponsor: CowParade Denver

Gilda the Gilded Cow | Stacy ROBINSON

Sponsor: CowParade Denver

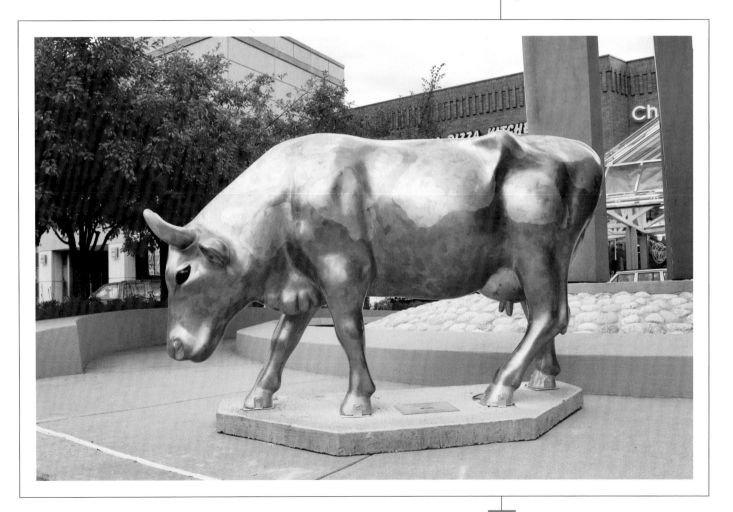

Cupcake | Diane FINDLEY

Sponsor: CowParade Denver

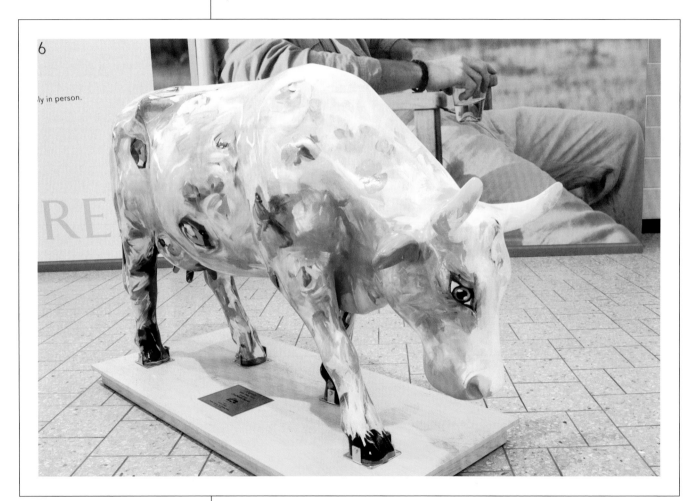

Moocho Fiesta | Alex KNUCKLES

Sponsor: United

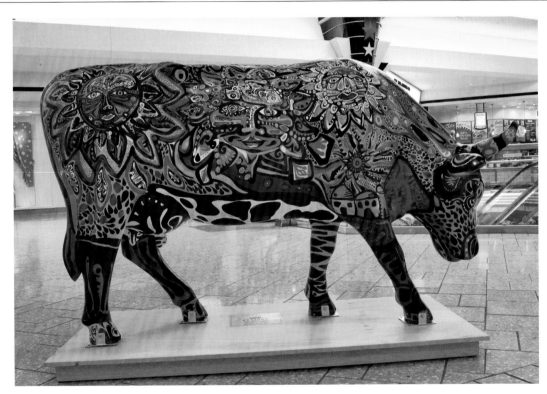

CHERRY CREEK SHOPPING CENTER

Moo-supial | Jay PAONESSA/ Juan Carlos RUIZ

Sponsor: United

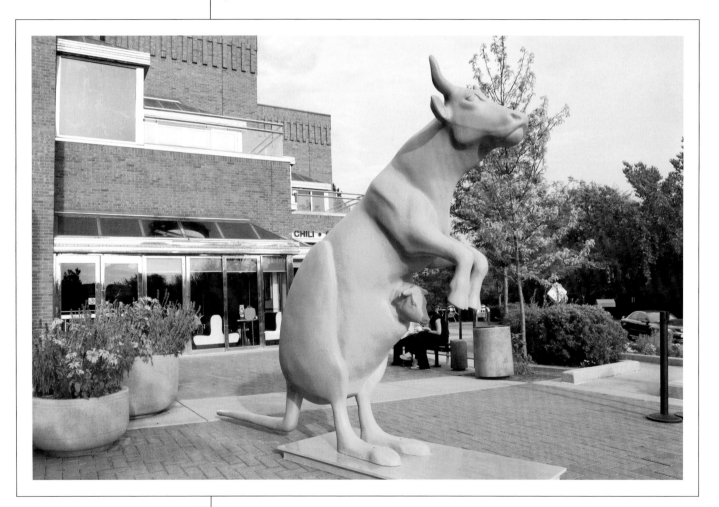

Post-Moos CoMOOnity Cow | Kim SHARP-LEYBA

Sponsor: Post/News Communities

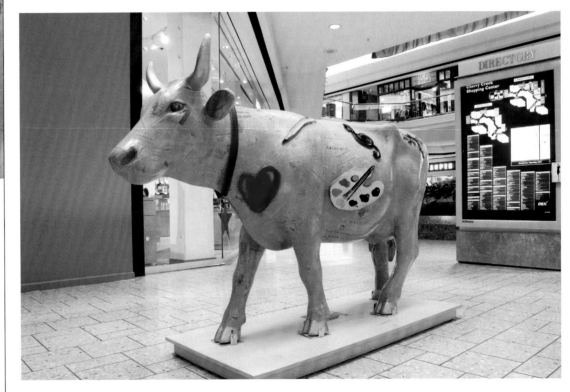

Macy's Thanksgiving Day Parade

Sean GRIFFIN

Sponsor: Macy's

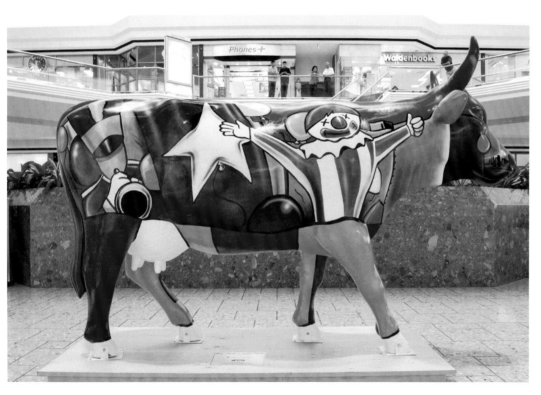

Enjoy the
colors of life!
Cecilia Sherry

Sedimental Moo'd | Cecilia SHERRY

Sponsor: CowParade Denver

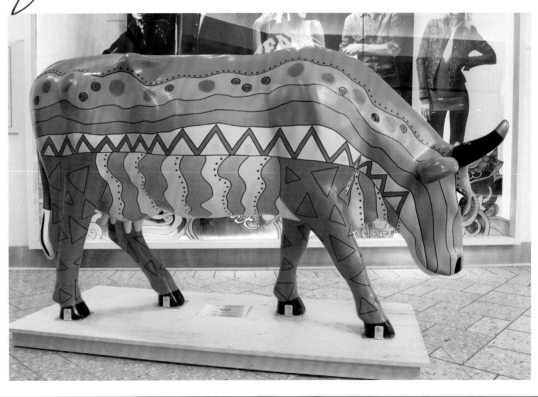

Moozart | Kim POLOMKA

Sponsor: CowParade Denver

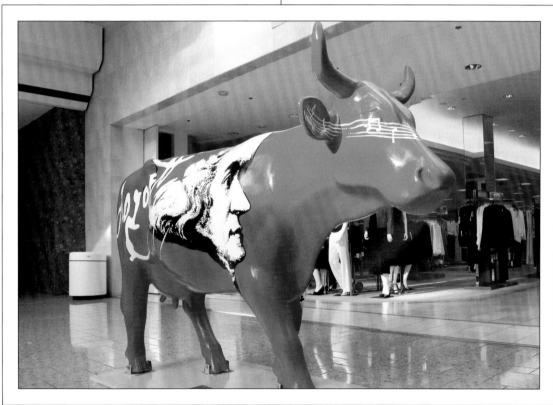

The Sunny Side of Vance Cowkland | Kym BLOOM

Sponsor: CowParade Denver

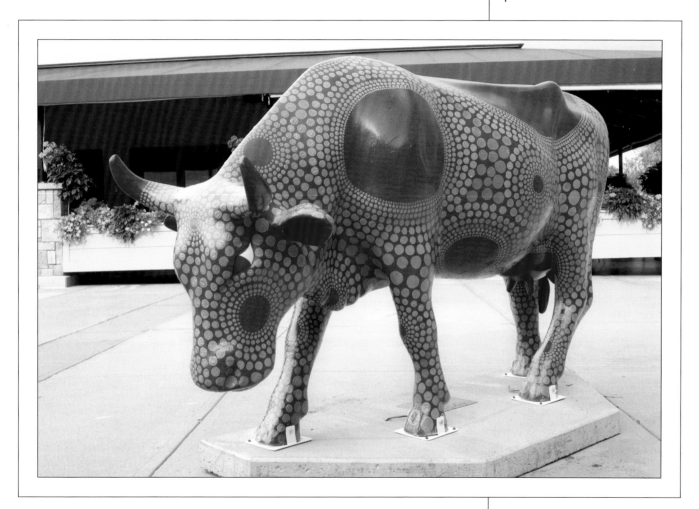

Splatter Cow | Terry WOMBLE

Sponsor: CowParade Denver

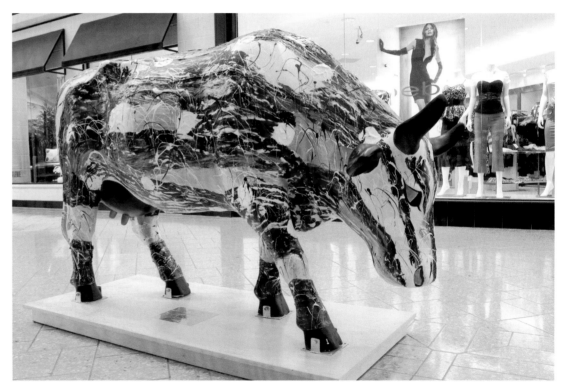

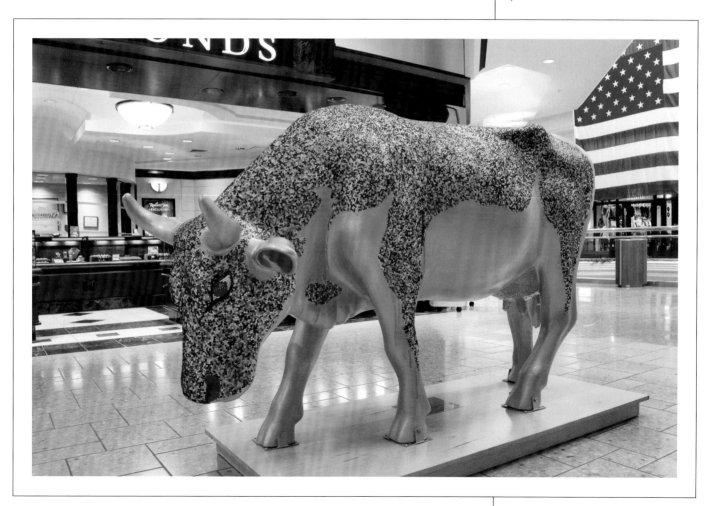

COLORado Cow | Juli SCHRADER

Sponsor: Children's Hospital

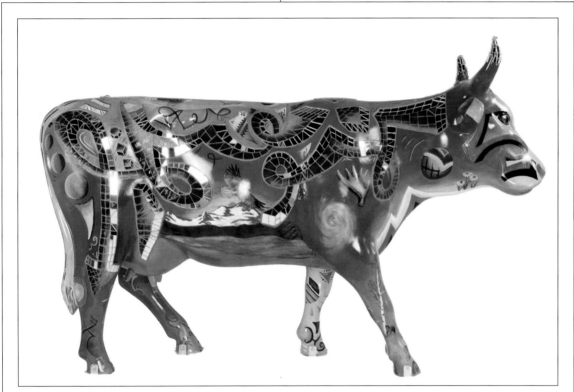

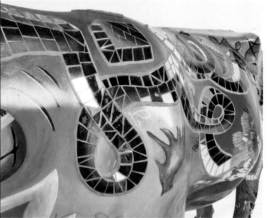

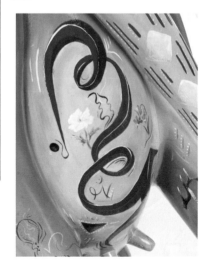

CHERRY CREEK SHOPPING CENTER

Juli Schrader

Sponsor: OppenheimerFunds

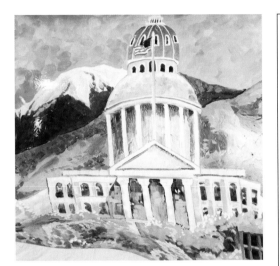

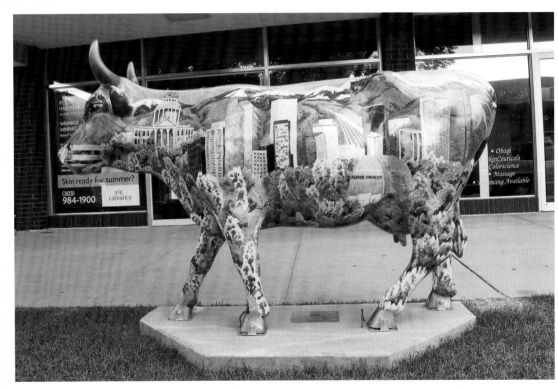

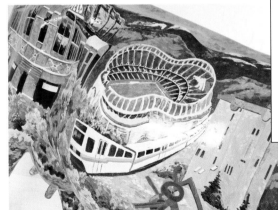

CHERRY CREEK NORTH

Get Along Little Doggy | Jennifer GRIGGS SEBASTIAN

Sponsor: CowParade Denver

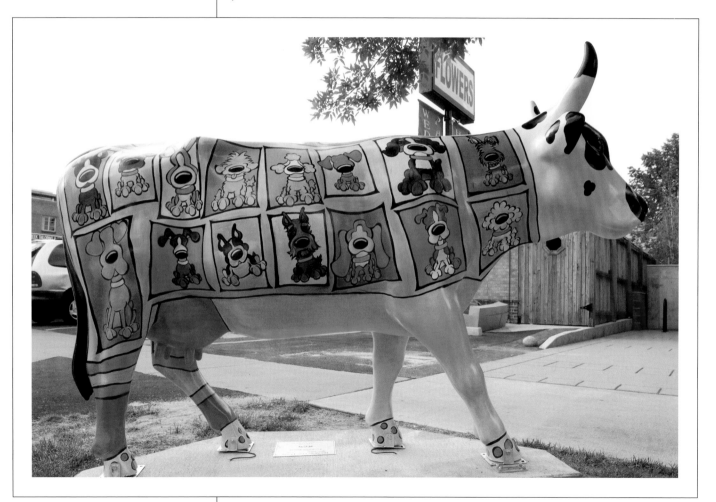

To Be the Purple Cow | Valerie & Jonathan NICKLOW

Sponsor: CowParade Denver

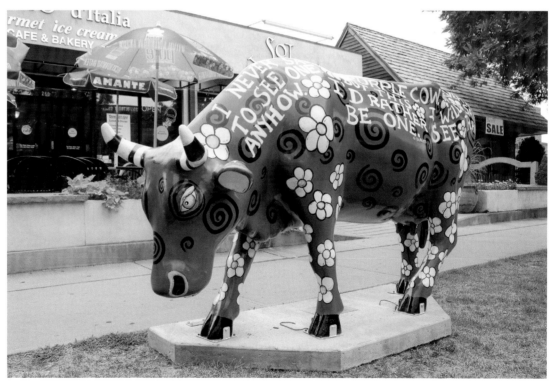

Americow | Maureen SCOTT

Sponsor: CowParade Denver

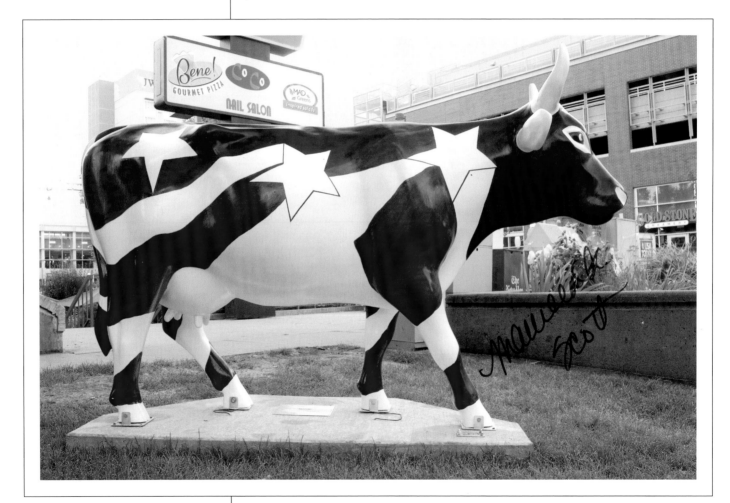

Cow Flower Power | Lisa HUFF

Sponsor: CowParade Denver

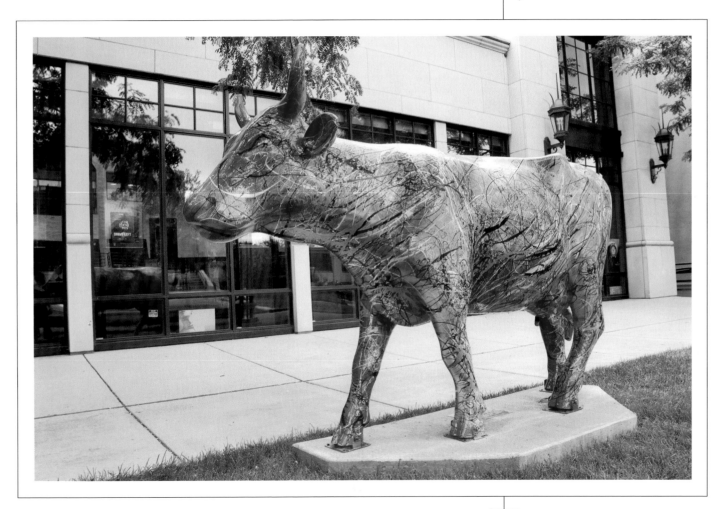

Stegobovus | Ren BURKE

Sponsor: 9NEWS

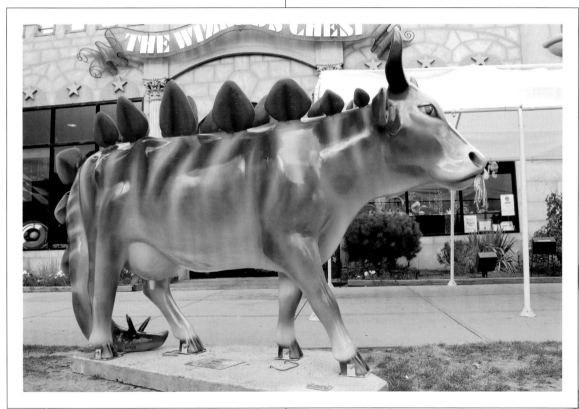

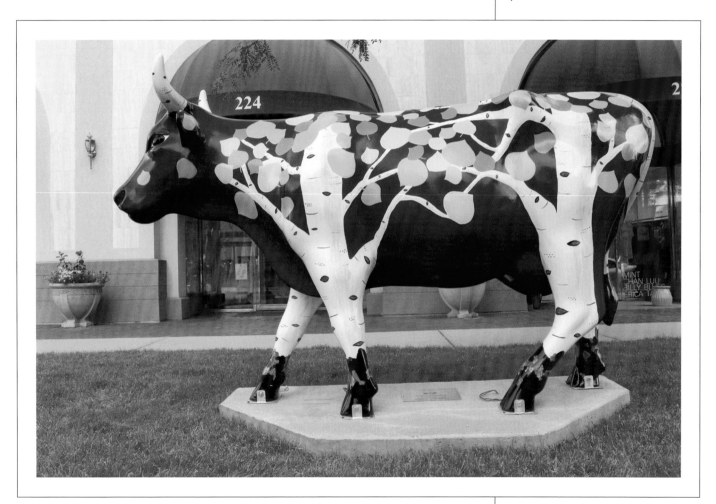

Sponsor: United

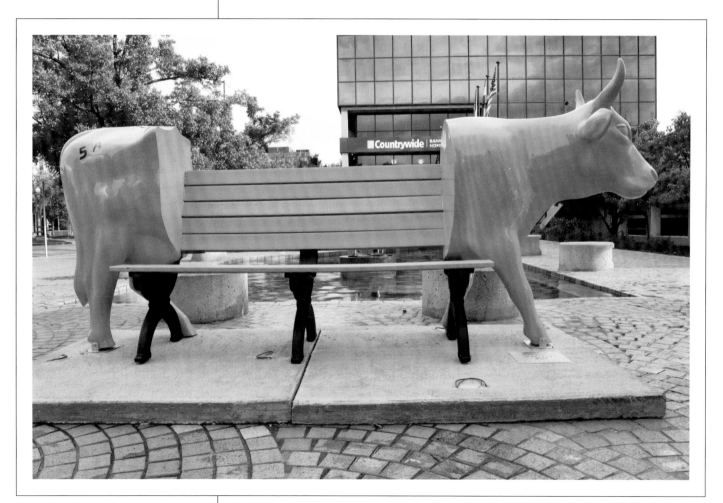

Beauvineyard | Lisa MATLOCK

Sponsor: Souders Studios/Square Pixels

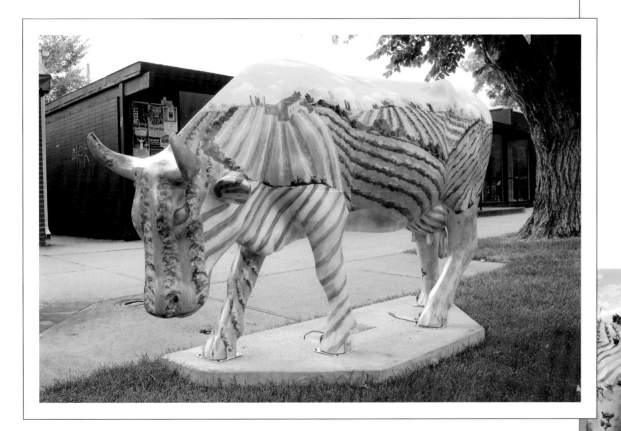

CHERRY CREEK NORTH

John Lynch BronCow | Joanne ORCE

Sponsor: Rainbow Rewards

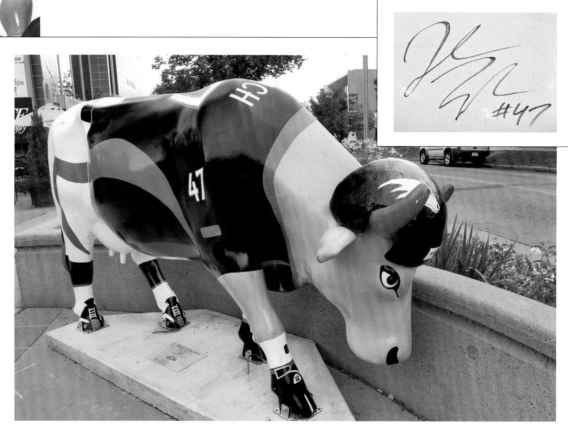

Mooprint | Nancy SEDAR SHERMAN

Sponsor: The Weitz Company

Happy Cow | Tim SMITH/Patrick MACKLIN

Sponsor: Horizon Organic

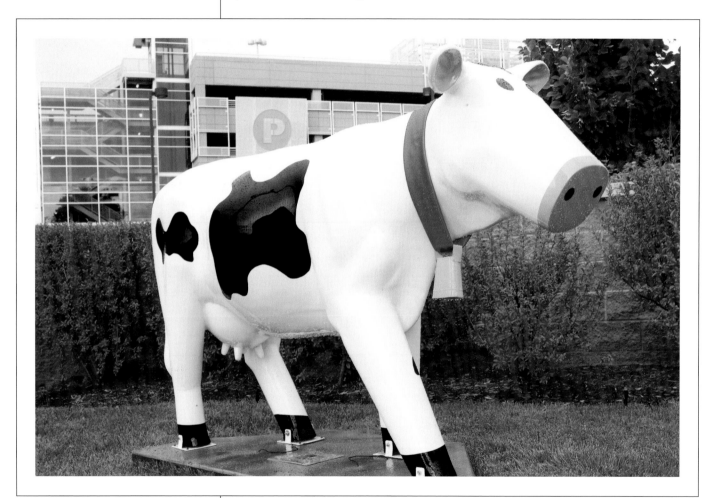

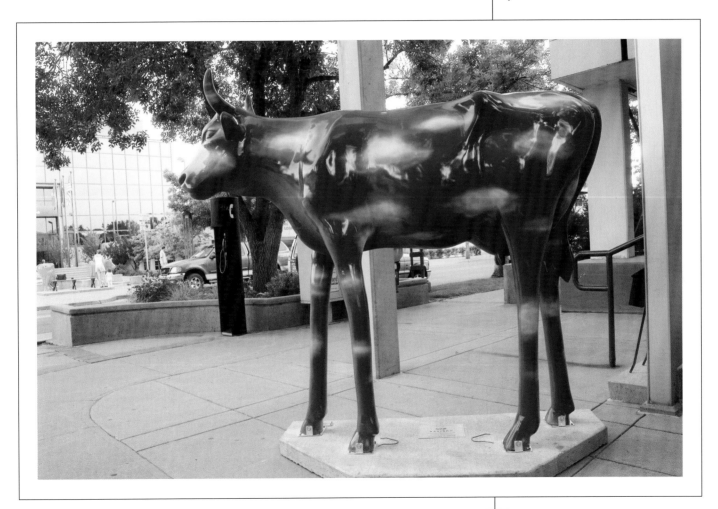

CHERRY CREEK NORTH

Optical Cowlusion | Andrean ANDRUS and Davis BERLIND

Sponsor: Colorado Beef Council

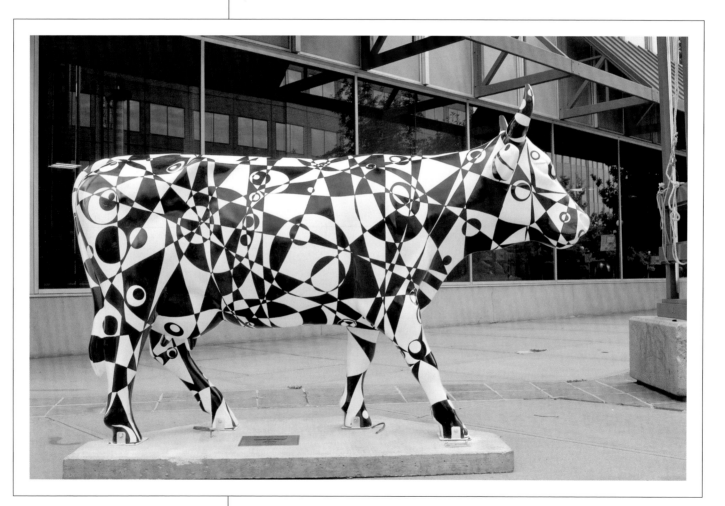

Mod Cow | Chuck POPPE and David W. THAYER

Sponsor: Crate & Barrel

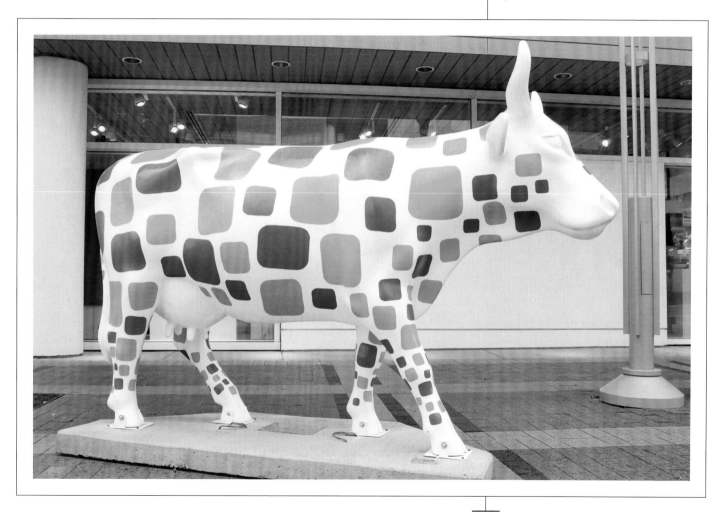

STAPLETON HERD

WATERING HOLES

- East 29th Avenue—Town Center
- Founder's Green

STAPLETON ™

FEELS DIFFERENT

It's Time to Moo | Jay PAONESSA/
Luis Felipe MOSQUEIRA

Sponsor: United

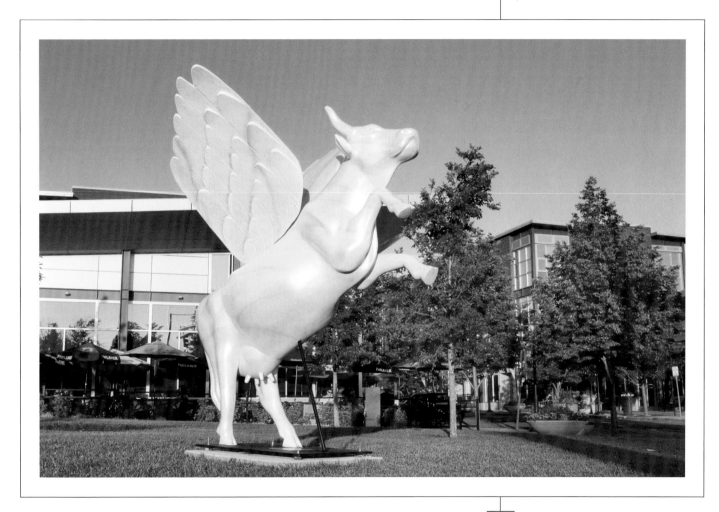

Moo-veau Organic | Marcy KERCHAL

Sponsor: Stapleton

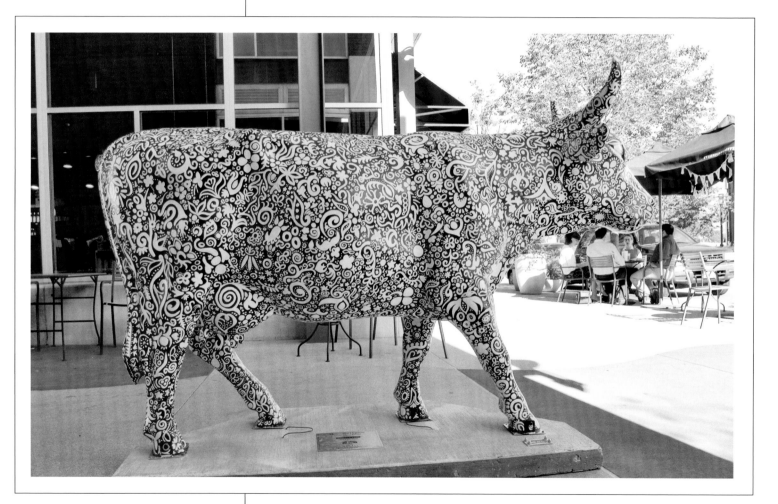

Moo-tanical Gardens | David WESTMAN

Sponsor: Stapleton

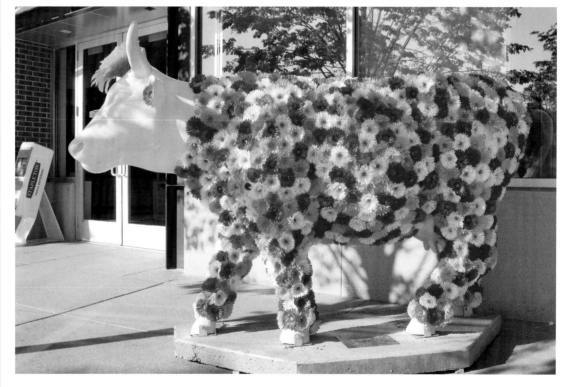

Climbing Cow | Susan DAILEY

Sponsor: Stapleton

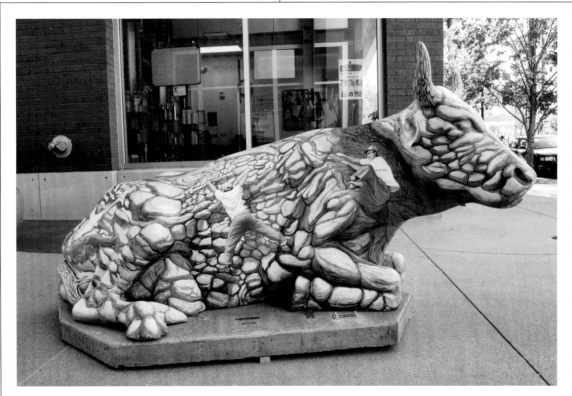

Cowabunga, Dude! | Elizabeth CRAIG

Sponsor: Stapleton

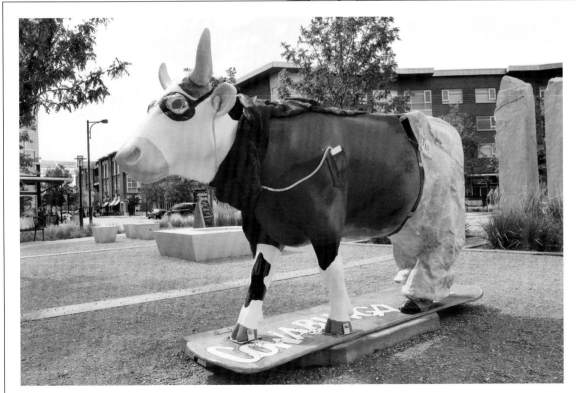

Udderly Green | Ann Marie AURICCHIO with Mandil Inc.

Sponsor: McStain Neighborhoods

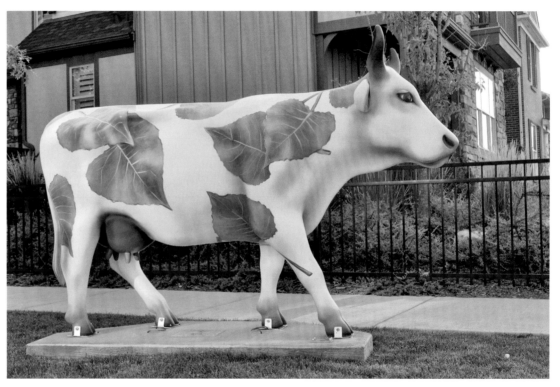

Botanica | Kim POLOMKA

Sponsor: Stapleton

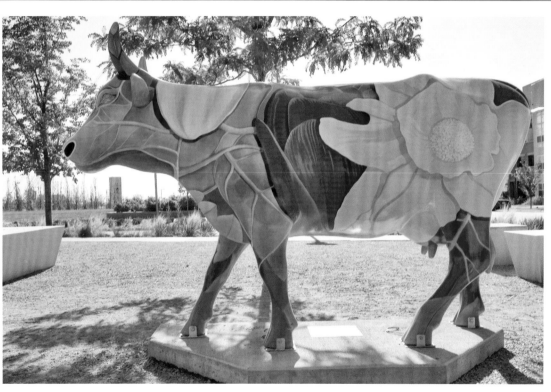

MooRine Life | Joanne ORCE

Sponsor: Stapleton

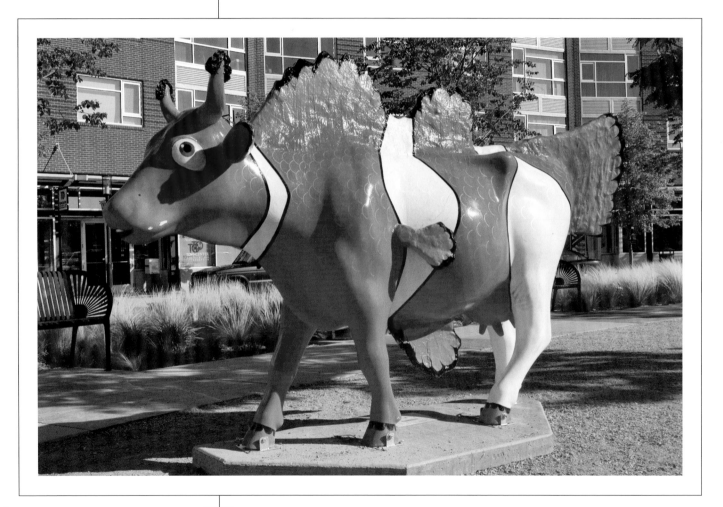

Madame "Butter" Flies | Kristel DECKX

Sponsor: Stapleton

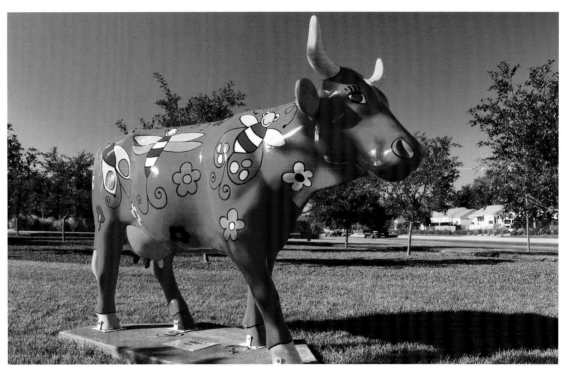

Jacques MOOsteau | Tanya HAYNES

Sponsor: Stapleton

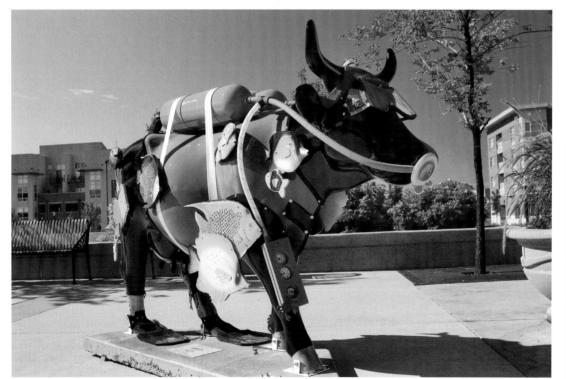

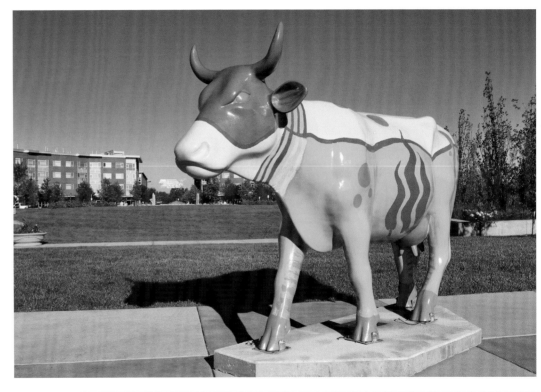

FOUNDER'S GREEN

109

Mooooticultural Cow | Starr T. & Merrill—Day Dreamz

Sponsor: Stapleton

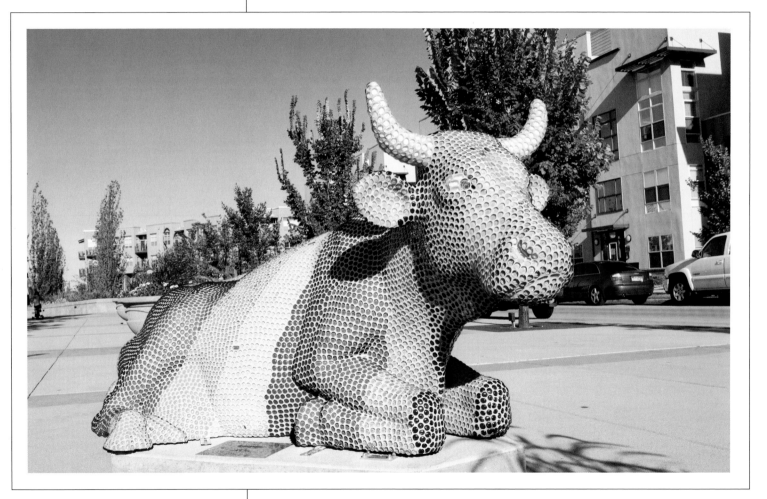

WATERING HOLES

- Children's Museum of Denver

- Denver International Airport

- Webb Building

- Wynkoop Brewing Company

PAINT BY UDDER | ANDREAN ANDRUS

SPONSOR: UNITED

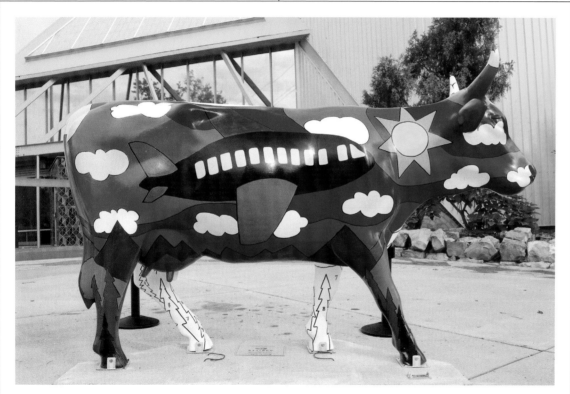

Sponsor: Netstructures, LLC

Rhapsody in Moo | Jay PAONESSA/ Roxann LLOYD and Amy CLIFFORD

Sponsor: United

Cross Country Cow | Pam SIRKO

Sponsor: Wynkoop Brewing Company

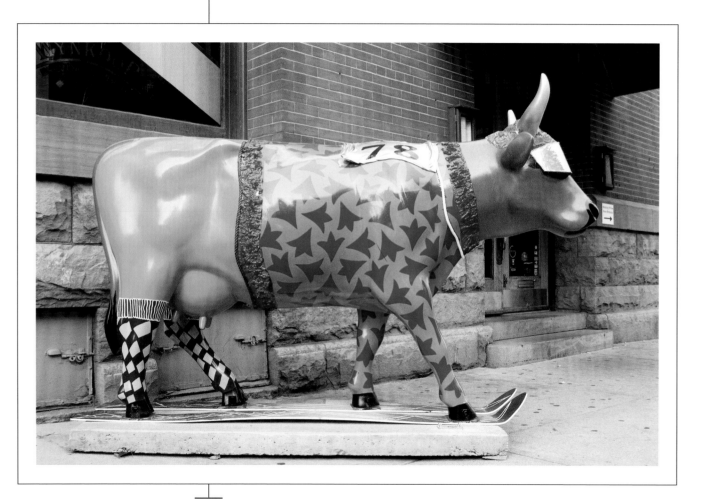

Jay PAONESSA/
Tim SMITH

Sponsor: United

Abstract Glazed Red Moo Rising | Steven ALTMAN

Sponsor: Mayor Hickenlooper

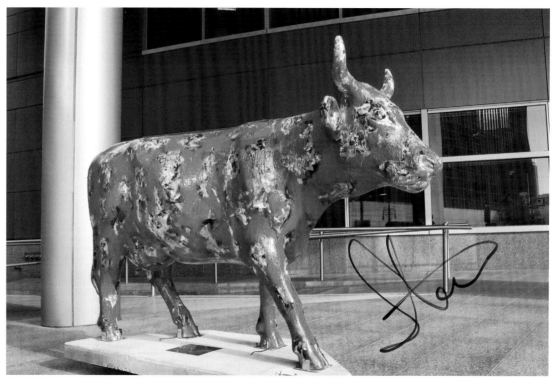

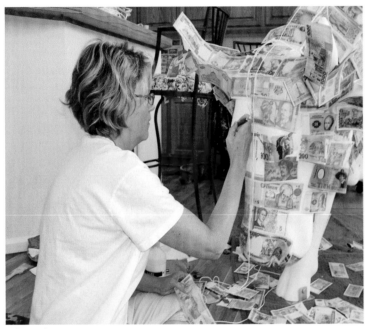

Cheryl CUSIK

CHERYL CUSICK
"MOO-LA"

Denver artist Cheryl Cusick loves money—but not so much for its value, as for its art. A former New York stockbroker, Cusick uses her knowledge of finance as inspiration for her work.

"My inspiration for creating 'Moo-La' was based on the business term 'cash cow.' It refers to a business that generates unusually high profit margins or a product that produces a steady and dependable source of income over time. This expression is a metaphor for a dairy cow, which after being acquired, can be milked for a long time with little expense. Every business yearns for a cash cow!" she explains.

"The term 'moo-la' refers to money," she says. "Lots and lots of money. The connection between money and cattle is simple. Around 6,000 B.C., cattle became the first objects used as currency. Other goods were assigned values in relation to a cow or oxen. Cattle served as a medium of exchange, as a standard of value, and could be stored."

"I interpreted "Moo-La" as a beautiful cow covered with the most colorful and decorative forms of money used in the world today." In fact, she collected currencies from more than 200 countries and applied them on the cow to create her bovine work of art.

Cusick is busy working on a book entitled *The Art of Money*, which will showcase the colors and designs of modern banknotes from around the world. "Every note is a work of art and every bill tells a story," she says.

Monte MOORE

Monte Moore is an award-winning professional illustrator and author of five books on fantasy illustrations. He thought he had done it all until he entered designs for CowParade Denver 2006.

"I thought I had painted it all—people, murals, cars, bikes, helmets, glass, boats—but never a cow." He said it reminded him of growing up on a ranch in Idaho where he showed cattle as a young 4-H member. "I hadn't painted a cow's hooves in 20 years, and that made me laugh that here again, as a professional artist, I was painting a cow's hooves." Although a professional artist, his family's business is involved with real cows. Moore, his parents and three brothers own Maverick Ranch Natural Meats whose products can be found in more than 2,000 stores nationwide.

His "Cow Town USA" creation illustrates why people who live in Colorado, love Colorado. "It features all four of our seasons, our national and local patriotism, Red Rocks, Capitol, Denver Mint, National Western Stock Show, mountain biking, skiing and state flower," he explained.

Moore, who lives in Aurora, has won the World Fantasy Art Show twice for "Best Black and White" artwork, and has created licensed art for Lucasfilm, Ltd., Playboy, Coors, Playstation, DC Comics, Marvel Comics and dozens of other properties such as Harry Potter and Dungeons and Dragons. His work has appeared in *Time* magazine, *Newsweek*, *U.S. World Report* and others.

Barry GORE

BARRY GORE
HIS COW: "IT'S YOUR MOOVE"

Unlike many of the CowParade artists, Thornton resident Barry Gore says he is not a professional artist. "But, I am creative," he counters. In his real life, Gore is a public relations and marketing professional.

His cow creation, "It's Your Moove" became a colorful magnetic canvas of overlapping game boards representing darts, checkers, chess, Parchisi, Chinese checkers, and games similar to Candyland, Monopoly, Bingo and Scrabble. Actual game pieces can stick magnetically to the cow. "It came about from a brainstorming session. One night while pondering my list of 50 possible ideas, I heard someone on a commercial or television show say, 'It's your move.'"

Creating the cow consumed almost five weeks of his life, he says. "We got to know a lot of our neighbors as they walked past the house and saw me working on the cow in our garage. It became quite a conversation starter. In fact, my entire family referred to it as 'our cow,' this and 'our cow,' that. It's almost as if we had a living, breathing pet cow."

Gore says from his perspective, art is universally appealing in the same way music, babies and puppies are. "People seem to let their guard down and open up to one another a bit more easily when they are fascinated, intrigued, entertained or provoked by something as extraordinary as a whimsical or fantastically decorated cow sculpture. I'm humbled by the creative genius evident in all of the CowParade designs and equally honored by the idea that thousands of people will see my cow."

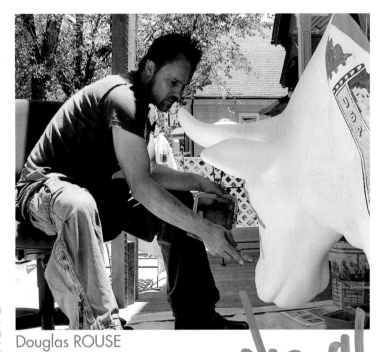

Douglas ROUSE

DOUGLAS ROUSE
"COLORADO STAMP(EDE)" AND "14,000 FT. COW"

In his studio located just west of Colorado Springs, award-winning artist Douglas Rouse literally put his stamp on two Colorado-themed cows.

"I simply tried to think up things that I had not seen somewhere already and I wanted a majority of the designs to be Colorado-specific," he said.

With that in mind, his first creation—"Colorado Stamp(ede)"—utilizes original art in which Rouse created large Colorado postage stamps and painted them all over the cow. His second cow took him to a higher level, painting all of the Colorado mountain peaks that are 14,000 feet or higher. "Mountains exist all over the world, but Colorado has 54, 14,000-plus peaks. That's what I'm celebrating with this one."

Rouse moved to Colorado Springs after spending nine years in Europe honing his artistic skills. Today, he's an award-winning 3-D street painter and has developed a reputation painting illustrations and renderings, faux and wall treatments, murals and Trompe L'Oeil, photography and computer art, modern mixed media, and music videos and film sets.

Joanne ORCE

Joanne E. O [signature]

JOANNE ORCE
"MOORINE LIFE, JOHN LYNCH BRONCOW, MT. BOVINE, COWLORADO AND RHINESTONE ROSIE"

Marine life, football, ski runs and rhinestones were the eclectic inspirational contributions Denver artist Joanne Orce made to CowParade Denver 2006. It was at her home where she developed her creations both indoors and outdoors. While working on "Mt. Bovine Cowlorado" (a lying down cow), in her living room, her two little girls would put a blanket over the cow each night to help it go to sleep. "He also was decorated by my daughters in feather boas and princess costume accessories when I wasn't looking," she says.

This cow became her favorite creation. It depicts a chain of ski runs off a mountain top complete with ski lifts, trees, amenities and a village at the base.

The "MooRine Life" cow is her most whimsical design. "I was trying to think of something that would appeal to the public, specifically children. A cow/fish that looked something like Nemo seemed bright and colorful. My kids loved this design," she says.

And, her "John Lynch BronCow," became her most publicly recognized cow. Named for Denver Broncos Safety John Lynch, this famous cow was spotlighted in a public ceremony where Lynch signed his name and number to the cow's rump.

"Working on cows is not like working on a regular canvas where you sit or stand in one spot and paint for hours until you are happy with your piece. I was constantly moving about the cow, mixing up fiberglass, cutting foam, lying under the cow, standing on chairs to reach the very top. Every night I would go to bed exhausted, but it was a great experience."

FEATURED ARTISTS

Acknowledgements | Moo'vers and Shakers

A SPECIAL THANK YOU TO COWPARADE DENVER'S "MOO-VERS & SHAKERS"

CowParade Denver required thousands of hours of work by hundreds of people. Each brought their own expertise, energy and resources. Without their spirit of community and service, this project would have never taken place. While we don't have the space to acknowledge all of our participants and supporters, we want to provide special thanks to some of the key individuals and organizations that helped to make CowParade Denver 2006 a reality.

SPONSORS
United Airlines
 Elizabeth Mason, Tanya Galer, Sue Kazlaw-Nelson, Jim Kyte
Forest City Stapleton
 Hank Brown, JuliAnne Murphy, Tasha Jones
Colorado Beef Council
 Tami Arnold, Fred Lombardi
Macy's
 Elena Gerardi

OFFICIAL SUPPLIERS
OFFICIAL COW BASES: The Weitz Company
 Don Gendall, Amy Gahagen,
 John Cochran
OFFICIAL BARN: Netstructures, LLC
 Zach Wilson, Fred McCoy, Fred Dawson

OFFICIAL MOO-VERS: Mortenson—Kerry O'Connell
 Apex Transportation—Glen McCormick
OFFICIAL PHOTOGRAPHER: Souders Studio—Rick Souders
 Square Pixels—John Wood
OFFICIAL DESIGNER: Stortz Design, Inc.
 Timothy Stortz, Carson Kraig
OFFICIAL BEER: "Milk Stout" Left Hand Brewing Company
 Chris Lennert
HOST HOTEL: Residence Inn by Marriott Denver City Center
 Brandy Sawyer
KICK-OFF HOST: Wynkoop Brewing Company
 Erica Bodley

HERD LOCATIONS PARTNERS
Downtown Denver Business Improvement District
 John Kearns, Kate Haher, Malia Campbell
Larimer Square
 Margaret Ebeling
Writer Square
 Monica Barrientos, Eric Ingram
Shops at Tabor Center
 Nina Thomas
Denver Pavilions
 Bethany Garner
Cherry Creek Shopping Center
 Lisa Herzlich, Karen Gilkey

ACKNOWLEDGEMENTS

Cherry Creek North
Christina Brickley, Lori Cowan
Stapleton
JuliAnne Murphy

MEDIA PARTNERS
The Denver Post/Rocky Mountain News
Tracy Ulmer, Carol Cline, Lee Bachlet, Tim Dubus
98-5 KYGO, Smooth Jazz 104.3 & KS1075
Dwayne Taylor, Paul Heling, Steve Conklin, Aldo
9News- KUSA
Steve Carter

NON PROFIT PARTNERS
The Children's Museum of Denver
Tom Downey, Gretchen Kerr, Nell Roberts
The Denver Zoo
Ben Duke, Tim Schuetz
Cherry Creek Arts Festival
Terry Adams, Tara Brickell
The Eagle Fund of the Denver Foundation
Ryan O'Shaughnessy, Brian Mankwitz, Brian Abrams
Denver Foundation
Betsy Mangone

CHARITY AUCTION STEERING COMMITTEE

Rollin D. (Rollie) Barnard Tom Fillipini
Mary Cronin Emily Fillipini

Michael Hancock Jane Norton
Chris Henderson Jeanne Robb
Emily Henderson Edward A. (Eddie) Robinson
John Hickenlooper John Skok
Walter (Walt) Imhoff Sue Stevinson
Georgia Imhoff Fred Taylor
Mary Louise Lee-Hancock Tracy Ulmer
Monica Liley Sherri Vasquez
David Miller

EVENT PRODUCTION TEAM
Bruce Erley, Creative Strategies Group (CSG)—Managing Director
Ron Fox, CowParade Holdings—Director
Julie Gore, CSG—Project Manager
Jill Lentz, CSG—Sponsorship Sales Manager
Brooke Amidei, CSG—Sponsorship Sales Associate
Jeannie McFarland Johnson, CSG—Media and Marketing Director
Kelli Turner, CSG—Client Services Manager
Matt Erley, CSG—Summer Intern/Cow Moover
Carol Hiller, Carol Hiller Events—Operations Director
M. Marta Sipeki, The InterPro Group—Public Relations Manager
Z.J. Czupor, The InterPro Group—Public Relations Manager
Michael Rieger, Lapis Gallery—Cows in Schools
Howard Smartt—Barn Manager

And all the hundreds of volunteer wranglers, without which nothing would happen!

Sponsor |INDEX

SPONSOR INDEX